THE NATURAL WORLD

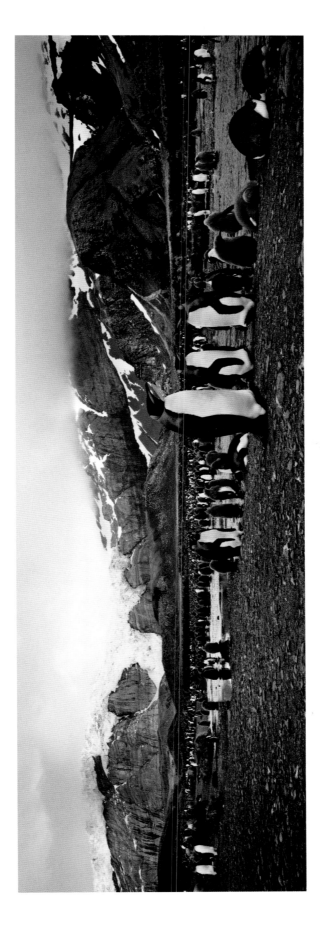

THOMAS D. MANGELSEN

FOREWORD BY JANE GOODALL

To Jane and Spence,
for giving me joy, inspiration and hope.

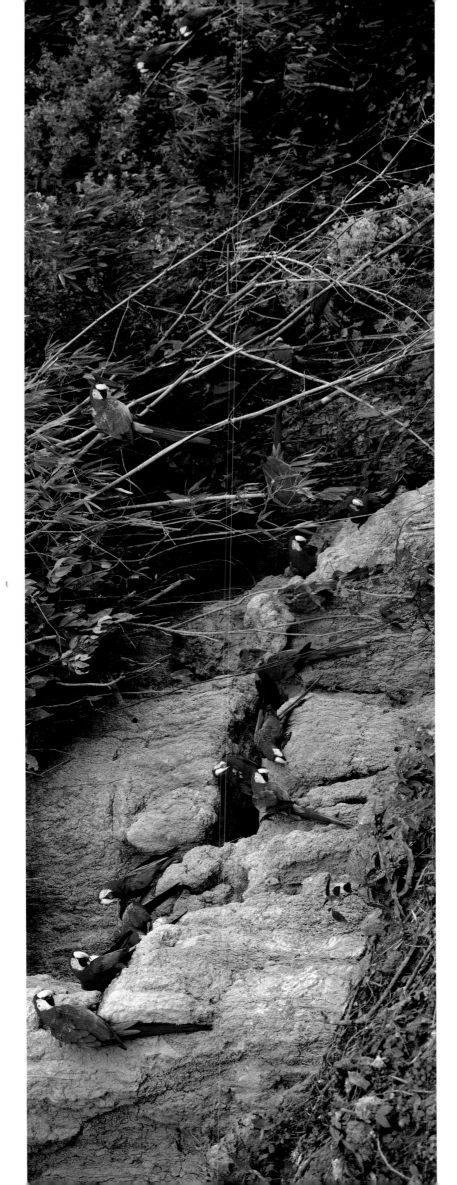

TABLE OF CONTENTS

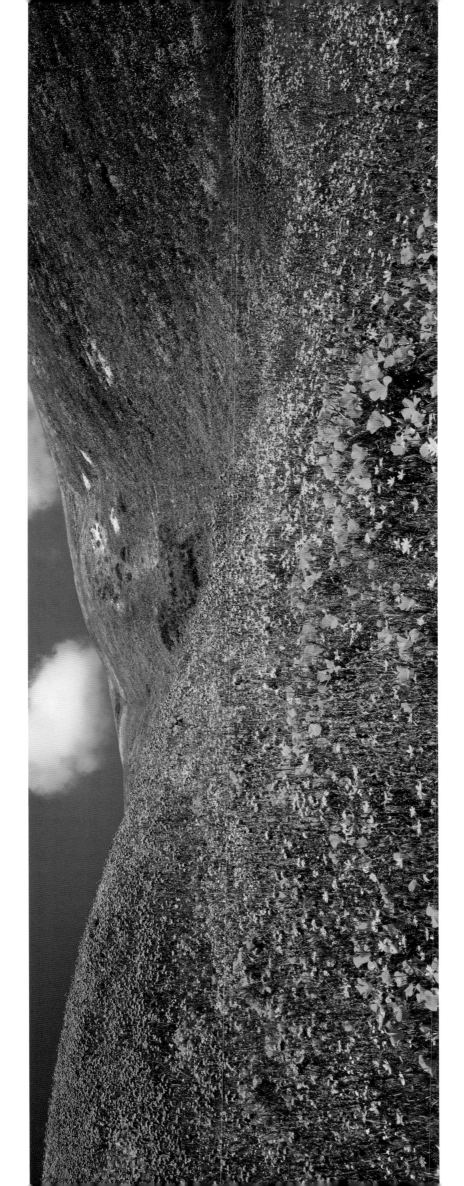

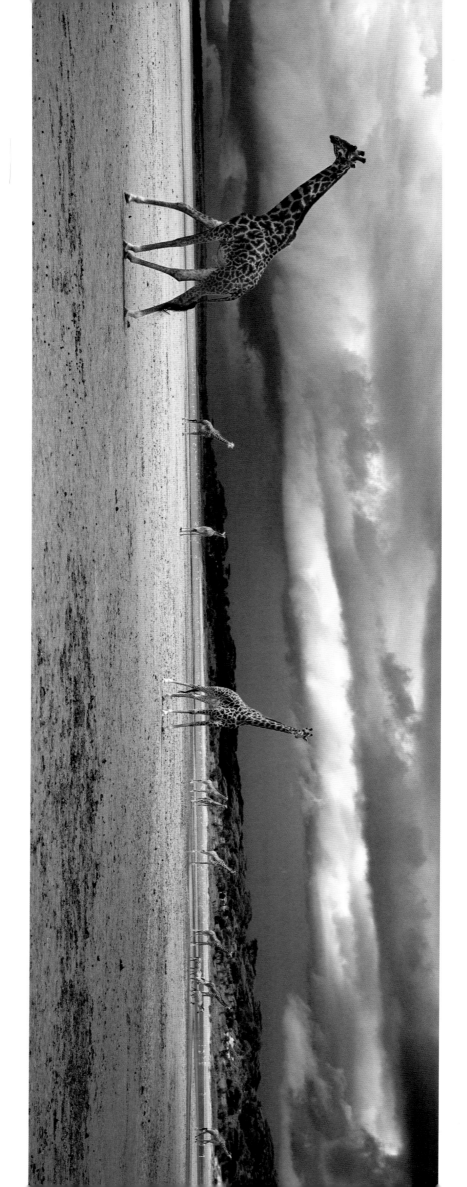

FOREWORD

The Natural World takes us on a remarkable journey on six continents, from the white wilderness of the Arctic, through the mountains, parks and valleys of North America, the jungles of the Amazon and India, and the plains and deserts of Africa. So often, when I visit wilderness areas and am spellbound by some glorious scenery, I feel a longing to capture the image so that I can take it away and look at it again and again. Alas, I never developed a talent for capturing nature with a paintbrush on canvas; Mother Nature painted with a grandeur that I could not even begin to imitate. And though I often tried to take photographs, they were dull and poor, bearing no resemblance to the glowing originals. And so I had to be content with my memories, mind-pictures of the wildness of remote places. Until, that is, I met Tom Mangelsen and went into one of his galleries, Images of Nature.

There I found myself in a magic place, for the breathtaking photographs around the walls transported me to faraway countries, some loved and familiar so that looking at them woke a yearning to be back, others that provided tantalizing images of other worlds I had yet to experience. Here, at last, were photographs that had captured not only the physical likeness but the very essence of the wilderness scenes depicted. And now, bound into a single volume in *The Natural World*, Tom presents the very best of the panoramic scenes that are his trademark.

As I got to know Tom the man, I understood better the secret of the success of Tom the photographer. It goes without saying that he is a master of camera technology. But that alone is not enough to produce the kind of images that have made him famous. Of course he has a passionate love of nature and wildlife. He portrays animals as individuals complementing and bringing focus to the landscapes where they live. And he feels with his heart as well as seeing with his eyes. It seems to me that he has the same kind of reverence for the spiritual essence of the wilderness as the Native American who believes that life on Earth is sacred, a gift from the Creator. It is this, I think, which enables Tom to capture, again and again, something of the soul of the landscapes he portrays, something beyond the mere physical shape of the land, the mountains and the sky. This enables him to share his insights into the being-ness of the animals and plants in his pictures. In addition, Tom has the sharp, observant eye of a keen naturalist. He understands as well as loves animals, knows about their behavior, knows what to look for, what to expect. And there is another element: Tom sees the world around him with the perceptions of an artist, composing his pictures as a painter might. Finally, over and above all this, he has unlimited curiosity, unlimited patience and all the determination of a perfectionist.

The Natural World is a glorious celebration of all of these talents in the glowing pages of one book. It will be difficult for most of us to choose a favorite scene. When I am nostalgic for my beloved Africa I can turn to the images of the Serengeti. How well I remember those days, when I was living there studying hyenas, watching the approach of rain clouds, praying for rain to break the long dry season. And if I close my eyes after gazing at the picture, the giraffe come to life, moving with their fluid, slow-motion gait across the burnt plains. I can even capture, fleetingly, the unforgettable smell of rain falling onto parched African soil. Or I can enjoy, with the lions, the tranquility of the evening before they set out for a night's hunting. Tom can transport me to a continent I love and miss.

The images from Yellowstone bring back vividly the day I visited the park for the first time, with Tom. There is the curious yellow glow of the rocks, the brilliant gold of the aspens in the fall, the sense of freedom conveyed in the soaring of a bald eagle. We saw so many other animals that day: from grizzles and black bears to an otter family playing in the river, grooming each other and the male stamping with his feet. There is something almost prehistoric in the landscape of Yellowstone with its moose and elk and lumbering bison, and the ominous bubbling of underground gases. And the smell of sulfur.

I have never seen hillsides covered with such richness of flowers as Tom has captured with his magic lens. Nor have I experienced the icy vastness of the Arctic, the extraordinarily powerful presence of the polar bear, a true sovereign of the frozen north. No wonder this is the animal Tom loves to photograph most, for it represents an extraordinary triumph of adaptability to a beautiful but hostile environment.

Here, in this fabulous collection, you can bring images of nature into your living room one by one. Set the book on an easel and open it at a different page each day, or each week perhaps. Fill your mind with the glorious vistas every morning to prepare yourself for the trials of the day. And again at night, so that the wild places surround your sleeping mind. Choose your favorite image and treat yourself to a full-size print from the catalogue.

I believe this book will stir in some a wanderlust they never knew they had and waken a desire for them to go into the wilderness themselves. I believe it will strengthen the commitment, shared by many who have experienced the wild places, to work to preserve them; and I hope it will inspire others to join that dedicated fellowship. Together we must ensure that the extraordinary beauty of nature, captured here, remains a reality.

How tragic if future generations would know it only from images captured on canvas or paper. They would never forgive us.

Thank you, Tom, for asking me to be, in this tiny way, a part of this magnificent enterprise.

Jane Goodall
Bournemouth, England, 2006

Founder, the Jane Goodall Institute &
UN Messenger of Peace
www.janegoodall.org

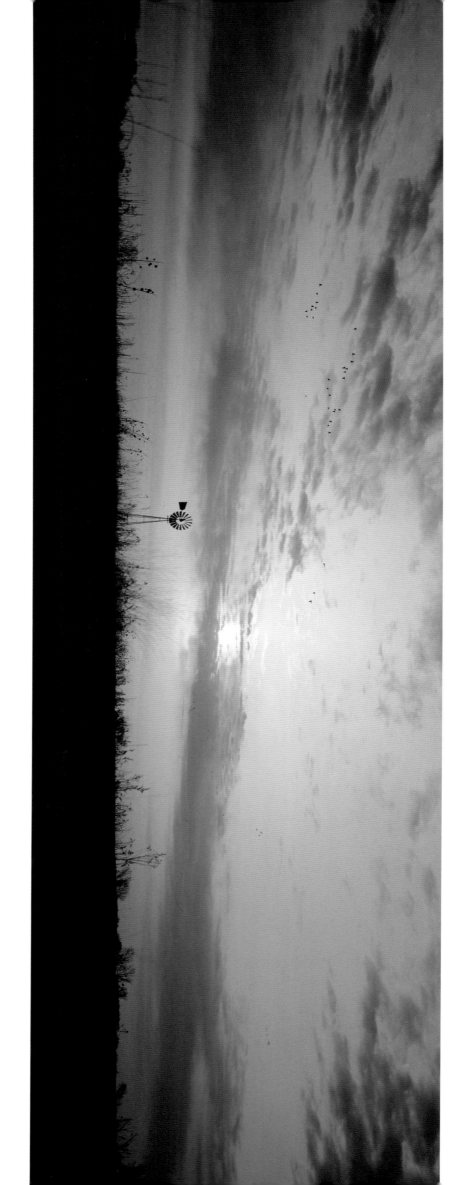

INTRODUCTION

Most of the photographers I've known and admired grew up taking pictures, usually with a Kodak Brownie or similar camera. A bit of a slow starter, I didn't take my first picture until the summer after I graduated from college. I was 22 years old. I never dreamed of being a nature photographer. My father assumed that I would follow in his footsteps; for him that meant staying in the family business, a five-and-dime store whose sign read, "Harold W. Mangelsen and Sons."

My career began in the prairies, I suppose, watching waterfowl and listening to the ancient and haunted cries of sandhill cranes. I was born in Grand Island, classic small-town Nebraska, near the Platte River, and spent my childhood years there and in the prairie town of Ogallala. As a kid I always had dogs and cats, but there were also chickens, ducks, geese, crows, raccoons and opossums; I collected frogs, turtles, snakes and lizards. My best friend, Mike, whose dad owned a ranch near North Platte, and our buddy Joey, who was Ogallala Sioux, and I spent our days fishing, hunting and searching for arrowheads and buffalo skulls along the river and in the Sandhills, western Nebraska's vast sandy grasslands. We dug worms for fishing and sold the surplus ones to the bait and tackle shop at Lake McConaughy. We shot bull frogs with our air rifles and sold the frog's legs to the local truck stop diner on old Highway 30 for thirty cents a pair, which was enough money for three packs of BBs and would keep us in ammo for several weeks.

After spending three years in Ogallala during the mid-1950s, my family moved back to Grand Island when my father's first store, Mangelsen's Variety, closed. With nowhere else to go, we took refuge in our little one-room cabin, a converted schoolhouse, on the Platte River. I was too young to grasp the idea of bankruptcy or losing one's "nest egg," but I remember a lot of nights spent kneeling together at my parents' bed, alongside my three brothers, Bill, David and Hal, as we'd say the Rosary and recite the Stations of the Cross. It was a difficult time for my family, but in many ways a magical time for me.

I missed Mike and Joey, and spent a lot of days messing around the river bottom with my dog Tinker, a small black and white toy terrier mix. My dad called me "the little river rat." I always carried my binoculars and either an air rifle, bow and arrow or fishing pole. I was fascinated with birds, especially waterfowl, cranes and great blue herons. I began to understand the river and recognized the plight of all the trapped fish, turtles, tadpoles and frogs stranded in the drying pools. And I also realized the bounty they provided for the mink, fox, opossums and raccoons. By myriad tracks left by the pools, I visualized much of the "banquet" that took place during the night. When I asked my dad about the dramatic change in water levels and the predicament of all the fish and frogs, he explained that it was due to the dams upriver and diversion of water for irrigation. For thirty years he fought the dam builders. He was the first "environmentalist" I ever knew.

The years growing up on the Platte and in the Sandhills were formative in that I always wanted to capture the essence of what I was seeing but never knew how. Hunting and fishing were exciting for awhile; however, as I became more fascinated with birds and animals and gained a deeper appreciation and respect for them, the less interested I was in hunting. As I watched the V formations of geese crossing the wintry sky against lone cottonwoods, I often wished someone were there to make a painting. Photography never crossed my mind.

Then I met Paul Johnsgard, professor of zoology at the University of Nebraska. He was not only the world's authority on waterfowl but also an avid pen-and-ink artist, prolific writer and photographer. Although my undergraduate grades were pretty mediocre, Paul agreed to be my advisor in graduate school, mostly, I think, because I had won the World Goose Calling Championship—twice—and he knew my family had a cabin on the Platte! I became his assistant and he became my mentor.

I didn't realize anyone could be so passionate and knowledgeable about birds. Paul inspired me, teaching me about animal behavior and bird photography. Birds in flight were the most interesting to my developing eye, and the most challenging. Freezing a bird in flight, on film, in those days was difficult, to say the least—this was long before auto focus or auto exposure. Inspired by Paul, I bought my first camera, an Asahi Pentax Spotmatic, one of the first SLR 35mm cameras. I also bought a 105mm Pentax lens, a 300mm Komura and a 400mm Vivitar—all manual stop-down lenses. This setup served as my kit for several years. When the Pentax camera body wore out, I switched to Nikon, which I still use for all my 35mm work.

Back then, there were depictions of how one might view an animal or bird through the crosshairs of a rifle scope or down the barrel of a shotgun, similar to how the majority of traditional sporting art and wildlife painters were working. After graduate school, when I moved to Boulder, Colorado, I met Owen Gromme, one of America's master wildlife painters. This changed everything. Owen was also one of the first wildlife artists to do limited-edition prints of his paintings, and many of his paintings portrayed the natural world's quieter moments, often emphasizing animal and bird behaviors.

A new world opened up to me. Books illustrating the dramatic paintings of Bruno Liljefors, considered the "grandfather" of animal painting, and the book *The Singular Beauty of Birds* by Louis Agassiz Fuertes mesmerized me. Fuertes was able to capture the "internal spark" of a bird unlike anyone had done previously and few have done to this day. Naturalists and artists like Roger Tory Peterson, Robert Bateman and Bob Kuhn, all with distinctive styles and techniques, have inspired me greatly. Then, of course, there are the paintings by Andrew Wyeth, which probably influenced me the most. Photographers like Henri Cartier-Bresson, who coined the phrase "the decisive moment," and Ansel Adams, whose heart and soul was not only in photography but in conservation, and others: Edward Weston, Ernst Haas, Elliot Porter and Dorothea Lange, all of them monumental in my development as a photographer.

In those early years of the 1970s I spent most of my time photographing the subjects I knew best: ducks, geese, cranes and bald eagles. Around that same time I also turned to 16mm cinematography, documenting the natural world with motion pictures, believing that films would be a more effective way to tell the story. I worked for a small company, West Wind Productions, and made a number of educational biology films for the University of Colorado. This experience led to five years working on films about the Platte River and sandhill and whooping cranes. While making *Cranes of the Grey Wind* for PBS and the BBC and filming the sandhill crane nesting ground on the Yukon/Kuskokwim Delta, I was introduced to Alaska. After seeing bears, caribou and the grand landscape in which they lived—places like Denali—I became interested in trying to capture a story in a single frame.

However, I found it frustrating and difficult to seize those moments that epitomized an animal in its environment on 35mm film. The 35mm format worked well for portraits of animals and birds and their behavior, but I always felt compromised in capturing the bigger landscapes, the overall picture of an animal in its environment, and wanted something different. In 1985, fellow photographer and friend Ed Riddell walked into my office and handed me a Fuji 617 panoramic camera with a 105mm fixed lens. Ed knew my style and suggested I try it. The camera was mostly used for photographing landscapes, and I knew of no one using it for wildlife. This medium-format view camera, with its three-to-one aspect ratio, changed the way I looked at photography. It provided a more realistic wide-angle view, without compromising the perspective of the scene. Today, the Fuji panoramic view camera accepts several interchangeable lenses, but all functions—exposure readings, f-stops, shutter speeds and focusing—are totally manual. The lenses are comparatively slow, and the depth of field shallow, which generally requires longer shutter speeds and special attention to any moving animal or bird. The camera is inherently challenging for wildlife photography, but also very rewarding if one gets it right. With the advent of digital photography and the ability to "stitch" frames together on a computer to create panoramic images, there is no longer a viable market for this camera and it recently has been discontinued. There have been many advances in camera technology since I began my career, and a number of changes in how pictures of wildlife are captured, i.e. digital vs. film and wild vs. game farm. Digital photography today has certain advantages over film, but film continues to be a valuable medium. It doesn't matter whether one uses film or shoots digitally; I believe photographs capturing a real event of the natural world should represent just that moment and not be manipulated later.

The most disturbing trend I see today is the proliferation of captive game farm photography. Unlike accredited zoos or rehabilitation and research facilities, these game farms exist for the pure pleasure and profit of photographers, publishers and game farm owners. In small, jail-like cages, every imaginable species of wild animal is enslaved, propagated, rented, sold and traded, from bears, wolves and cougars to wolverines, raccoons and opossums to Siberian tigers and snow leopards. Oftentimes these animals are shipped together on a flatbed truck from Montana to Minnesota, Utah and Arizona to be placed in their "natural" habitat, photographed and then have their likeness published in books, calendars, magazines and on prints. It's a sad day for wildlife and for photography.

The Natural World represents only a tiny fraction of the Earth's extraordinary landscapes and amazing diversity. This book is a personal selection of images from those places and species that have touched me deeply and changed my life. I have been to places like the Serengeti and Denali many times; however, places like Iceland and Sossusvlei I have experienced only once. All, in one way or another, have been special gifts; some are now threatened to be taken away. Few of the places are the same as when I first visited them. Hudson Bay's polar bears were thought to be thriving when I first went there twenty years ago; today some scientists predict that because of global warming, polar bears will be gone from Hudson Bay and possibly elsewhere as soon as twenty years from now. The Earth is at a crossroads never before experienced. My hope is that we begin a new path, one of enlightenment, understanding, appreciation and tolerance for all living things. May *The Natural World* remind you of all the gifts of the Earth. And with those formative years steeped in trapping raccoons and skunks, shooting birds and animals, maybe my photography is a way for me to attempt to pay back, in some small way, those childhood indiscretions.

Tom Mangelsen
Moose, Wyoming, 2006

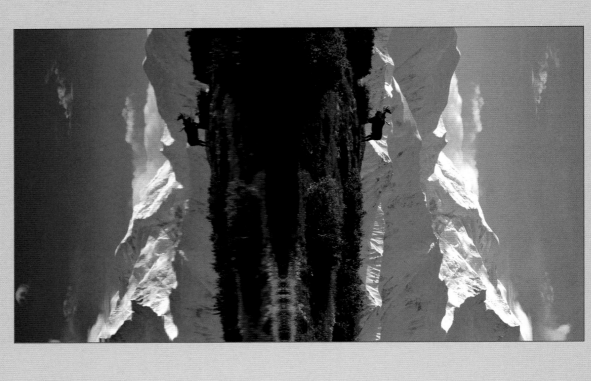

DENALI

September 1998

As we rounded the curve in the road above Wonder Lake, Chip Houseman and Helen Gromme waved to us from the edge of a tall stand of alder, a hundred or so yards below the road. They were obviously trying to get me to stop. I couldn't tell what they were excited about, but I figured it was either a moose or caribou. The first rose-colored light was touching Denali's 20,320-foot summit, and I knew from the direction Chip was pointing his camera that the moose or caribou was between them and the mountain.

This wasn't my normal photography trip to Denali. My friend Michael Fitzpatrick, at 53, was in his final stages of brain cancer. In the back seat of the camper was Spence Wilson, my 85-year-old "surrogate" father. Both were a bit shaky on their feet. Because of the similar impacts of their conditions—which mostly affected their balance and walking—Michael and Spence, who had never met before this trip, bonded immediately and sort of adopted each other. Although we had talked about them joining me in Denali for a number of years, it had never happened, and I knew this likely would be our last chance.

Chip was motioning for us to come quickly, and Michael and Spence, the consummate good sports, wanted to go but sensed my dilemma in having to wait for them. They urged me to go ahead and said they would catch up. I was reluctant to go without them, but grabbed my cameras and headed down the hill. When I turned and looked back, I saw Michael and Spence tripping over the tangle of dwarf birch, both falling, then

taking turns helping each other up. They were mumbling and cursing one moment at life's dealings and roaring with laughter the next. I couldn't help laughing myself. In spite of their handicaps, they were having more fun than possibly the rest of us. It was a glorious Indian summer morning in one of the most beautiful places on Earth.

I quietly made my way through the alder and then realized what all of Chip's gesturing was about: There stood a magnificent bull moose, just seventy-five yards below, with the Alaska Range and Denali in the distance. Just past the bull, in another stand of alder, was his harem of three cows; they already were moving up the hill toward a small pond. I knew the bull would follow. We turned back and went to the opposite side of the pond, hoping the bull might go up on the small rise and be silhouetted with Denali in the background. As we hurriedly went to the far side and scrambled down the steep embankment to set up, I saw the bull coming through the alders toward us and into the scene I had previsualized, and hoped for, with Denali's reflection on the water. The odds that the moose would walk into the clearing were probably one in twenty and the odds of him actually stopping there were even greater, but we knew if he did it would be wonderful.

Chip and I rushed to get our tripods set up. The bull was moving more quickly than we had anticipated, following his cows, and then suddenly he stopped in the clearing. It was the *perfect* scene. But, just as I was about to press the shutter release, he lay down. Chip just missed it, too. We both did a little "jig" out of frustration in the willows and said a few not-so-muffled four-letter words, both at ourselves and at the moose! Both systems, Chip's 16mm Arriflex movie camera and my 617 panoramic, take time to set up; changing lenses, leveling the tripod, taking handheld light readings and checking composition and distance is invariably slow and frustrating. We had just missed the perfect scene! Then we turned to each other and I said, "Well, he'll get up sooner or later and maybe we'll have another chance." We fine-tuned our compositions and exposures, and Michael and Spence finally caught up with us, frantically asking, "Did you get the shot?" We all waited.

Chip and Helen were shooting a documentary for ABC television; we had all been best of friends for many years. I had known Helen since she was a baby. Her grandfather, Owen Gromme, was one of the world's great wildlife painters and had been one of my early mentors. Now I had become a mentor to Chip. He was 35 years old and Helen 28. Helen worked in my gallery in Jackson, Wyoming, and I had introduced her to Chip. They were a team, she doing sound recording and he the filming; they had fallen in love. The previous May, we had traveled together in India, along with our friend Cara Blessley, to photograph and film tigers.

Four hours later, the bull stood, noticing one of his cows was on the move. The breeze had quieted and the pond was like glass. He looked around and contemplated the situation for a few seconds before moving down the hill and out of sight. It was better than we had imagined. We walked to a higher vantage point, where we could observe the moose, glassing the McKinley River bar for cranes and grizzlies. We picked ripening blueberries, ate lunch, lay on the tundra and talked about the wondrous morning. Michael kept asking, "Did you get the picture?" He didn't believe me until he received a large, framed *Reflections of Denali* for Christmas. Michael had not only bought the first of my limited-edition prints twenty-three years earlier, but was the one who encouraged me during those years when I needed it most. Though we had been best friends for decades, he had never gone photographing with me. Now, he finally understood.

Just a few months later, on December 17, 1998, Chip and Helen were killed in an airplane crash while filming macaques in the jungles of Thailand. Michael succumbed to his brain tumor the following spring, on April 25, 1999. As I write this, on July 4, 2006, Spence, at nearly 94, is "still kicking," as he loves to say. We talk every day.

Since this beautiful September morning, I have returned to Denali many times, but no Indian summer morning will ever be as memorable. Some experiences and some photographs are obviously more meaningful than others.

Mirrored in one of the many tundra ponds below the Alaska Range, a bull moose in the shadow of Mount McKinley epitomizes the grand scale of Denali National Park. The brief, brilliant colors of autumn light up the tundra, transforming the subarctic landscape into a multicolored patchwork of birch, willow and bearberry.

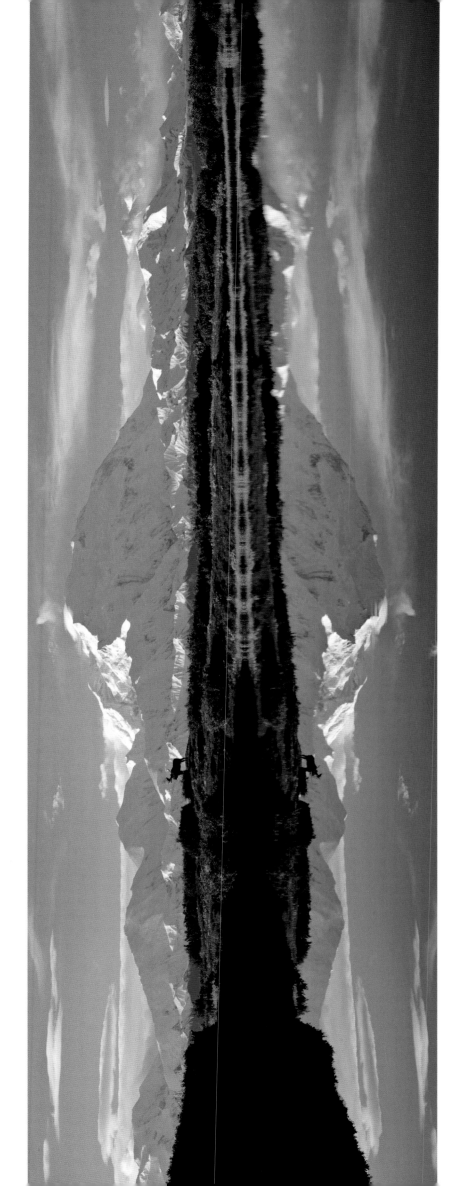

Reflection Pond, Denali National Park, Alaska, USA, September 1998

With winter closing in, ripening berries across Denali draw a mother grizzly and her three young cubs down out of the high country. Even though the grizzly population of Alaska is estimated at around thirty thousand, more than two thousand grizzlies are killed every year in the name of sport. This figure stands in harsh contrast to the approximately one thousand individuals that remain in isolated habitats in the Lower 48, mainly in and around Wyoming's Yellowstone National Park.

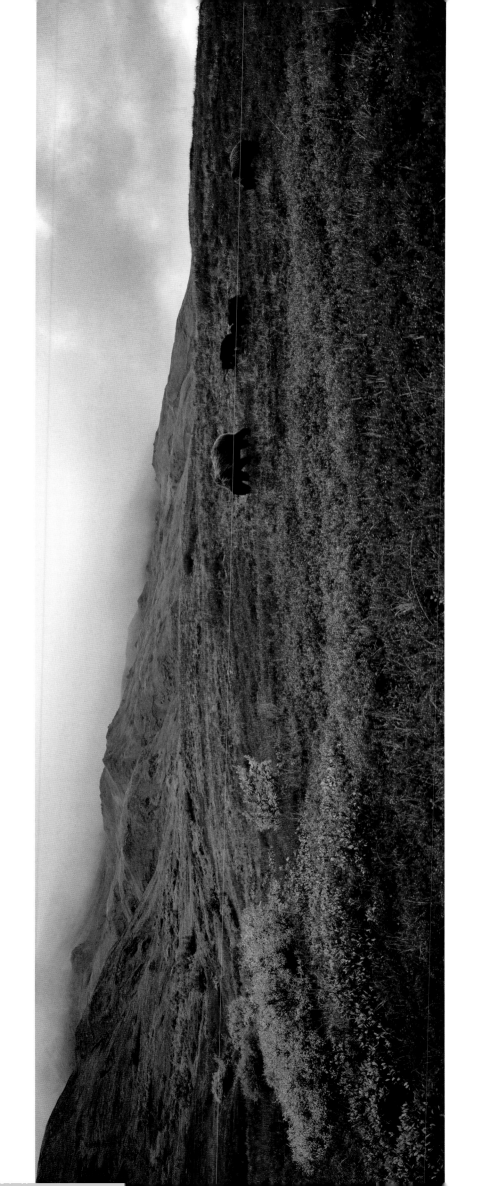

Thorofare Pass, Denali National Park, Alaska, USA, September 2003

17

Sun melts snow in striated formations along the barren mountainsides of the Alaska Range, nourishing rich lichens and ground cover along the steep slopes. A plentiful tundra ecosystem at the mountains' base is a key draw for migratory birds: Hundreds of species representing six continents will crest these peaks on their way to favored nesting grounds.

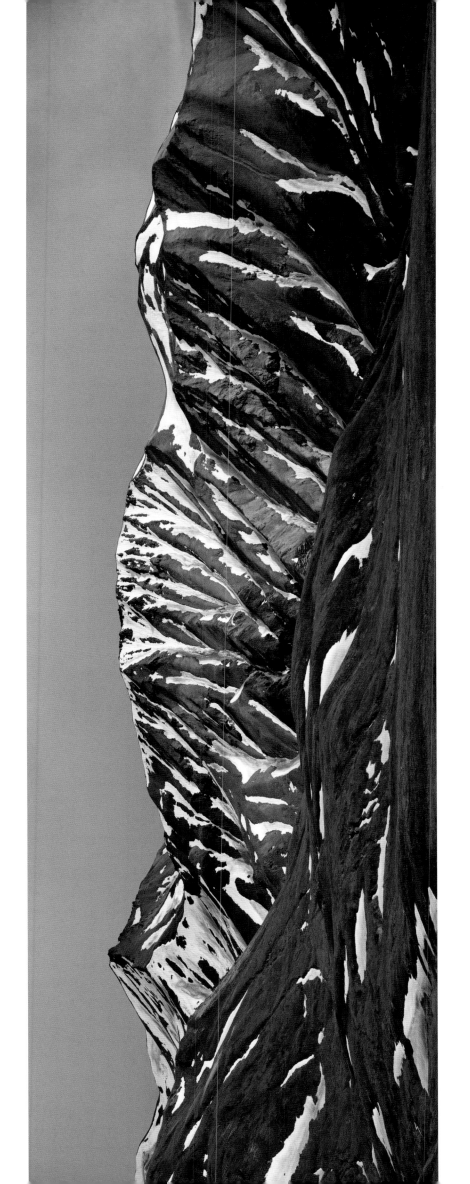

The broad and silty McKinley River bar threads its way along the western side of Denali National Park, serving as a roosting area and way station for sandhill cranes, especially during inclement weather. Once the weather clears and pending favorable northerly winds, the cranes will follow the Alaska Range east then south to the Central Flyway and their winter destination, either west Texas or Mexico. During the first days of September the cries of cranes reverberate above the clouds, but their prehistoric silhouettes are rarely seen.

McKinley River, Denali National Park, Alaska, USA, September 1998

The serene landscape above Jenny Creek conceals its rich fauna behind a screen of shrub birch: Here live willow ptarmigan, snowshoe hares, lynx, red fox, wolves, grizzly bears and moose. The autumn colors signify an especially dynamic time for *Alces alces gigas*, Denali's subspecies of moose and the largest deer in the world. For several weeks the bulls engage in heated sparring, the males transformed into raging adversaries during the annual ritual of the rut.

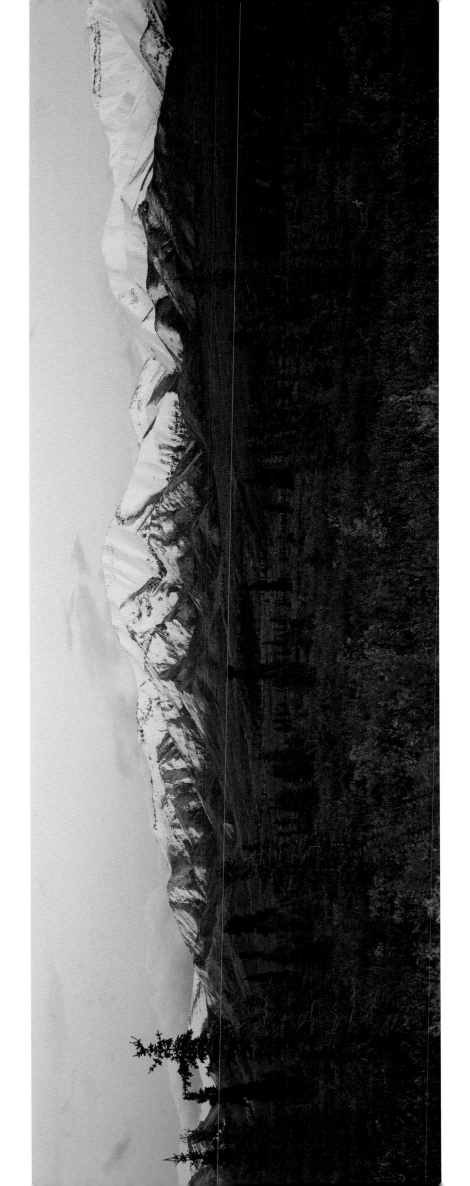

Jenny Creek, Denali National Park, Alaska, USA, September 1998

A colony of survivors in a harsh northern land, a grove of aspen trees endures by the grace of a single and often centuries-old network of roots. Enduring extreme climates is built into these trees' make-up. Delicate leaves survive brutal winds because they are attached to strong, flat stems, lending the leaves the fluttering appearance of the tree's Latin namesake, Populus tremuloides.

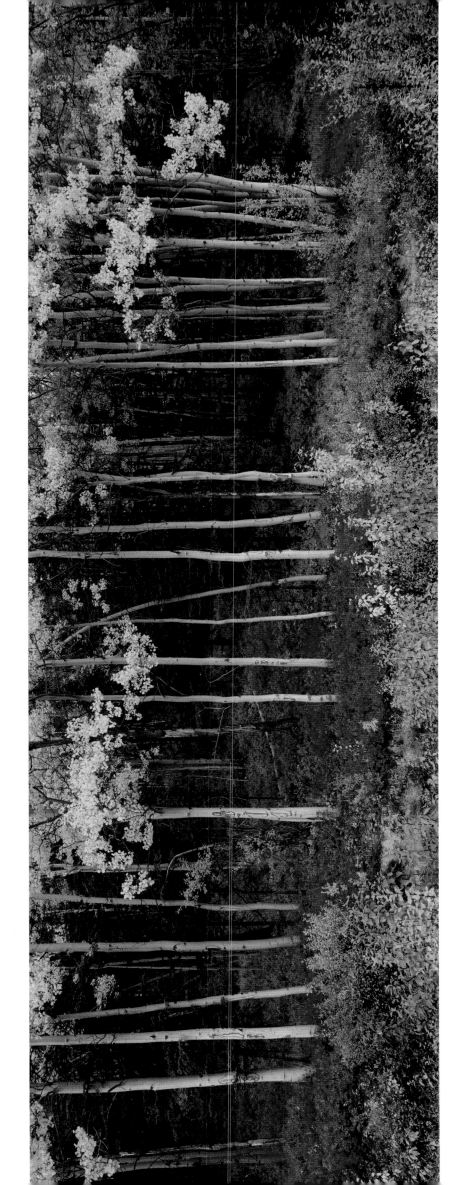

Riley Creek, Denali National Park, Alaska, USA, September 1992

Denali's classic caribou country includes taiga, a unique northern coniferous forest found in regions of the subarctic. This terrestrial biome is the largest in the world and serves as a major source of oxygen for our Earth. Here, three bull caribou browse on autumn vegetation. While the males develop giant racks, the females—unlike any other antlered North American ungulate—grow short antlers, an adaptation believed to help them compete with males for food during scarce winters.

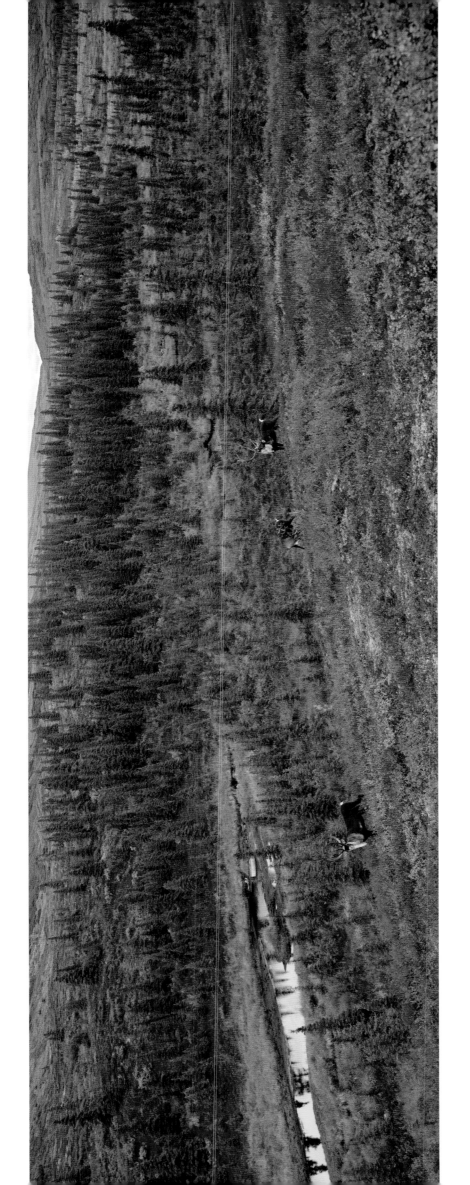

Moose Creek, Denali National Park, Alaska, USA, September 2001

No mountain in the world matches the breathtaking height and bulk of Mount McKinley, given its exposed vertical rise of 18,000 feet as seen from the floor of Denali National Park. Because less of its peak is exposed, even Mount Everest—at 29,000 feet—appears shorter than "the Great One," Denali.

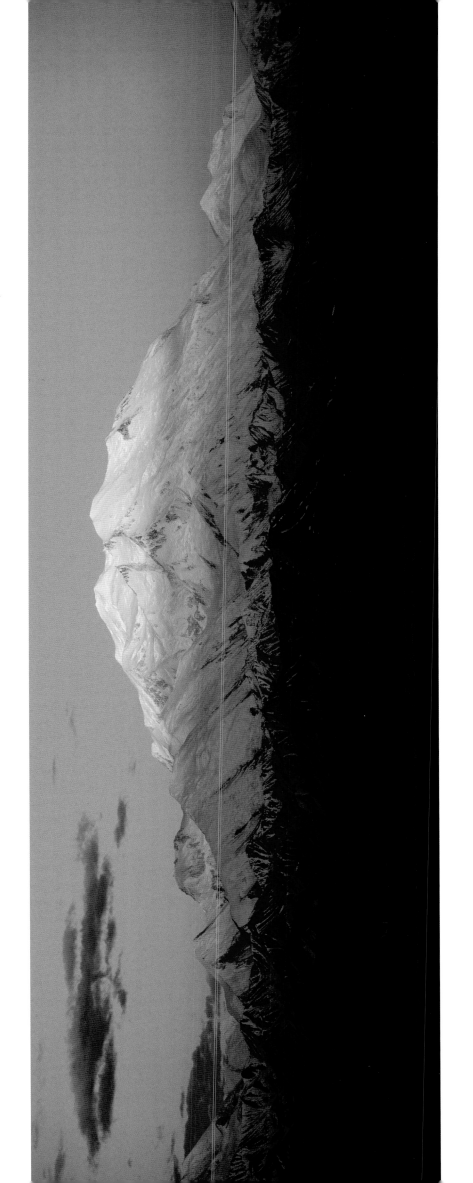

Denied the fatty riches of his coastal cousin, the salmon-fishing brown bear, interior Alaska's grizzly is dependent on the calories, sugar and immune-boosting vitamin C provided by vast quantities of ripening berries. Grizzly bears will travel many miles a day, spending hours feeding on the heaviest berry-laden bushes they can find.

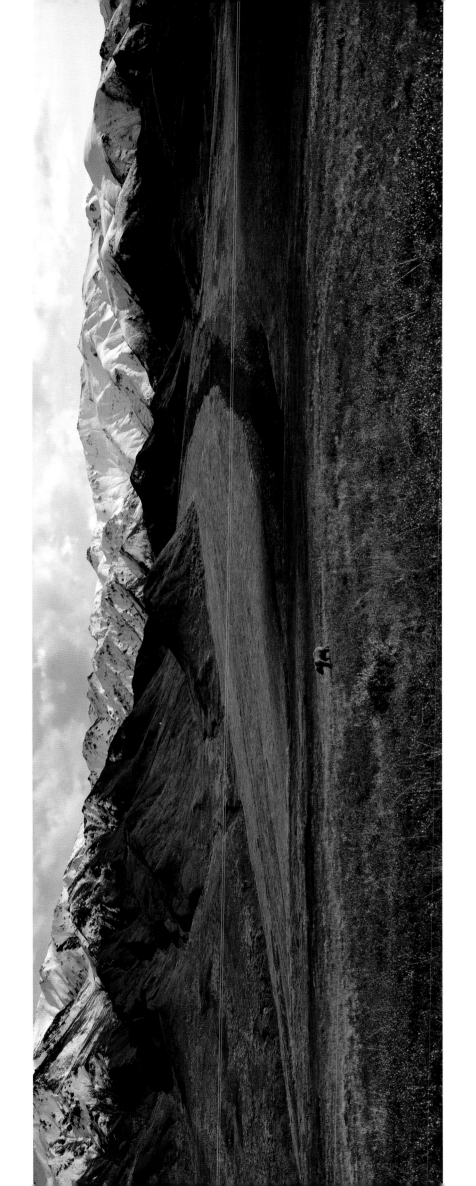

Highway Pass, Denali National Park, Alaska, USA, September 1992

Denali's grizzlies don't live on berries alone. The bears also rely heavily on moose, caribou and dall sheep, and spend hours chasing and digging small arctic ground squirrels from their burrows. As both an omnivore and an opportunist, grizzlies seize the chance to steal a wolf's kill. But turnabout is fair play in the animal kingdom—sometimes a pack of wolves will chase a grizzly from its kill.

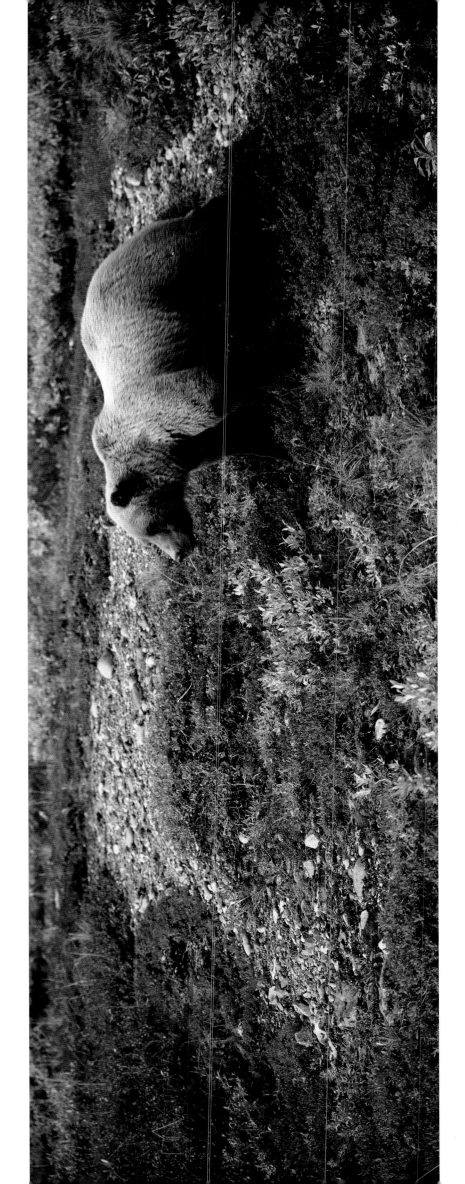

Stony Hill, Denali National Park, Alaska, USA, September 1998

Polychrome Pass gifts expansive vistas across the five-mile-wide Plains of Murie—named after the famed wolf biologist and author of The Wolves of Mt. McKinley, Adolph Murie. The multicolored hues of the landscape result from minerals in magma that erupted onto the Earth's surface around fifty million years ago. A kettle pond—formed by large blocks of ice left behind by receding glaciers—catches the last light before the storm.

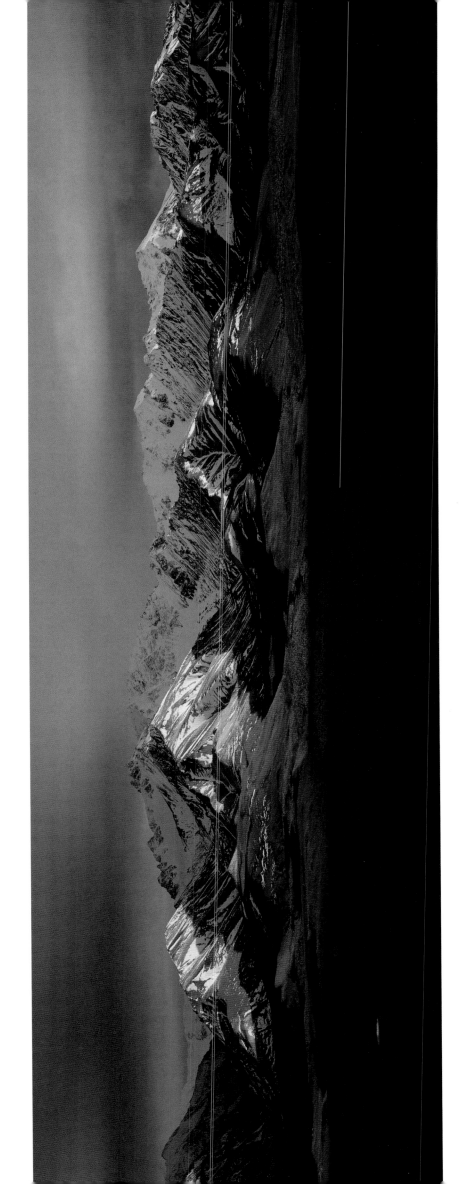

Polychrome Pass, Denali National Park, Alaska, USA, September 1998

One of Denali's largest bull moose guards his harem of nineteen cows. To attract females and improve their chances to breed, bull moose scrape a wallow with their hooves and then roll in the urine-laden mud. Strong hormonal scents dominate the scene as a younger and much smaller bull takes his turn in the master's wallow, mimicking the old bull's behavior in hope that the scent will win him the favor of a receptive female.

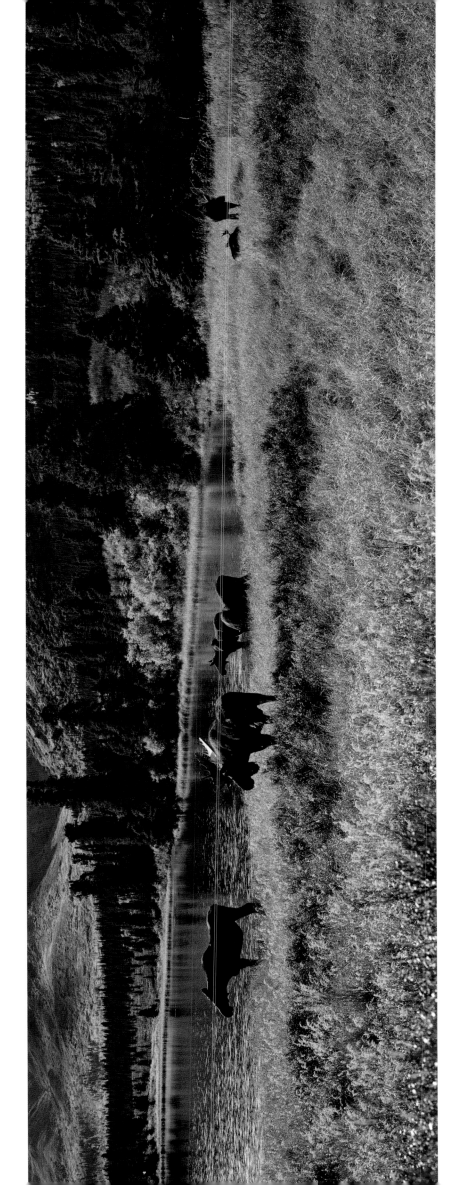

Igloo Forest, Denali National Park, Alaska, USA, September 1998

A looming bull moose rises to his feet to keep watch over his harem as it moves down the valley to wait out the night. To the west, the first snow squall of autumn dusts the highest peaks. Soon all of Denali will be blanketed in white.

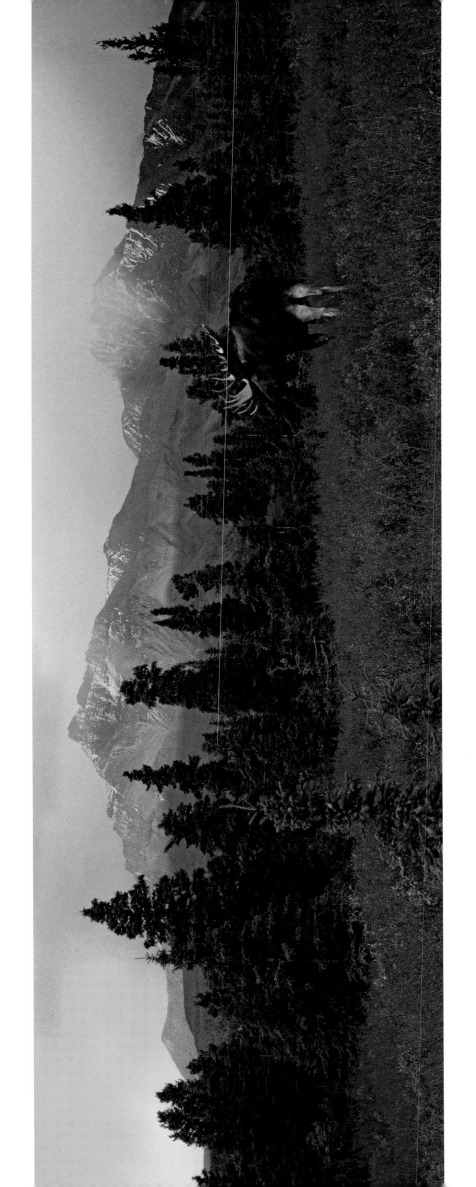

Igloo Forest, Denali National Park, Alaska, USA, September 1998

NAMIB

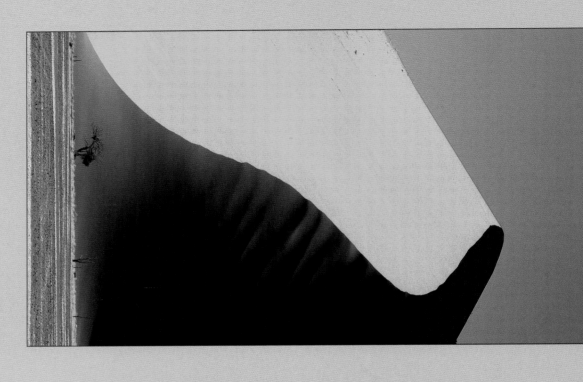

February 2003

Towering cumulus clouds dot the horizon as we fly northwest out of Johannesburg, South Africa. Below, the lush riparian forests soon give way to bushveld as we cross the southwest tip of Botswana and enter Namibia. A thick haze hangs over the land. There is little sign of humans, only a few dusty vehicle tracks following dry river beds speckled with fig and acacia trees. Dust swirls up behind small herds of goats and their herders. The land is arid and overgrazed.

We land in Windhoek, Namibia, where we switch planes from the South African 747 jet to a single-engine four-seater. The moment I enjoy least when traveling has arrived. Thiele Robinson, my friend and assistant, is pushing one of the overloaded airport luggage carts across the tarmac toward our plane, as I follow along with another trolley. The front wheel of hers catches in a deep crack in the concrete and spills over, then nine stumbles, dumping all the cases, tripods and duffle bags. Standing beside the plane watching our antics is the pilot, who can't be much more than twenty years old. He runs over to help us gather our gear, although he appears anxious at the prospect of fitting everything into the plane. Thiele and I survey what looks like a small car crash and laugh nervously, knowing the pilot is saying, "Oh shit" under his breath. No one is better at traveling and making light of these situations than Thiele, and I'm glad for it. At times like this it doesn't hurt that she is young and pretty, with big brown eyes. Her smile isn't lost on young Travis, and I realize we could have brought even more gear! Travis, not too surprisingly, says there may not be room for me, but somehow he finds space for everything, including myself. Then he says, "Let me give you a crash course before taking off." I had never heard it said quite like that before. We fly northwest toward Damaraland and the Skeleton adds, "If we make it and depending on the winds, it is about a two-hour flight to your tented camp." We fly northwest toward Damaraland and the Skeleton Coast and soon lose the bushveld and grasslands and enter the Namib desert, a magical land of sand dunes, considered the oldest and tallest dunes in the world. It's vast. It's hot. I realize the "crash course" was nice but likely a waste of breath—there would be no walking out of here and little likelihood anyone would ever find us.

The white dunes are huge, undulating and sculpted. I search for interesting patterns and shadows. Travis changes altitude, circling here and there as I click off frame after frame out the open window. Thiele is squashed in the rear seat, struggling to reload the panoramic camera between her knees, her face turning a pallid green. I gesture and over the headphones suggest she let me do the reloading and that she watch for elephants and oryx. She nods and agrees. The furnace wind and engine noise coming in my window is deafening, and the smell of oil and exhaust is turning me the color of Thiele. We had planned on an earlier departure out of Windhoek to avoid the mid-morning desert thermals and thin air, but it is too late. With the Skeleton Coast coming into view, we see the power of wind and sea and sand. Several intermittent rivers run through the area; most are blocked by the advancing dunes, creating pools of blue water and ephemeral oases. I imagine herds of the rare desert elephant—there are fewer than six hundred remaining, gathered around the oases—but only their tracks are left in the sand. Travis increases the plane's speed to keep us afloat on the thin air, and the images and patterns of sand dunes pass in a blur. I shoot quickly and wildly, but miss most. We circle back, but the view is never the same on the second go-round.

We follow the coastline north of Swakopmund, with its white sandy beaches and shallow bays teeming with flamingos, and continue our search for elephants. Rocky outcroppings jut out to sea, big surf rolls toward the beaches, and the skeletal remains of ancient shipwrecks are everywhere—hence the name "Skeleton Coast." Some of the ships that went aground on this treacherous coastline still lie in the rocks, waves crashing over them, while others rest far inland, preserved by the shifting sands; only their hulls or masts remain visible. It's an incongruous and eerie sight.

Shortly after noon we land on a gravel airstrip fifty miles from Torra Bay on the Skeleton Coast. It's like landing on the moon. The plains are stark and vast, covered in red volcanic rock. The vegetation is sparse; small bundles of yellow grass struggle to survive amid the prehistoric welwitschia, quiver and ghost trees. The distant mountains are subtle but impressive. Our tented camp, a cold shower and a scotch and water around the campfire are welcomed. Compared to the cacophony of night sounds in the Serengeti, the land here is quiet. As a full moon rises, tranquility and solitude reign.

Pastel shades of pink and purple greet the dawn. A mountain chats call is the first bird sound of the morning, followed by the soft cooing of mourning doves. At 5:30 a.m. we grab our thermos of tea and basket of fruit and bread and load into the open-topped Land Rover. The desert air is cool and crisp. Gerhard, our driver and guide, suggested last night that we leave early and head toward the Huab River to search for elephants. Gerhard navigates the Land Rover down the mountain on the narrow, winding and rough lava road. A small band of greater kudu, one of several species of antelope that live in this region, watches our progress from above. It doesn't take long to realize that Gerhard is a skilled driver. I compliment him, and he discloses that he does a lot of "rally" driving across the Namib.

By the time we reach the Huab, the sun crests the mountains and its warming rays strike the acacia-lined riverbed. The Huab flows only a few times a year, usually from rains that fall many miles away, but now is bone dry. Gerhard points the Land Rover south down the sandy wash and in low gear keeps it moving, fearful we may get bogged down in the deep sand. Several miles downriver we spot signs of what we had come here for. Gerhard pulls over on a dry mud bar, and we get out to look at the huge tracks of an elephant. We measure the imprint of a front foot, comparing its size to Thiele's hand with fingers spread wide; ten of her hands fit into one elephant track.

We follow the tracks down the dry wash, passing a pair of kudu and a half-dozen smaller springbok, and soon spot piles of fresh elephant dung. Not far away stands its owner, a magnificent bull elephant feeding methodically but delicately on the yellow-flowered verbana plants covering the river's sandy banks. He pays little attention to our arrival as Gerhard shuts off the engine. As the day warms, the old bull moves ponderously down the wash, casually grazing the sparse grasses and browsing the green leaves and thorny branches of young acacias. Elephants here are the heartiest in Africa, often traveling fifty miles a day to find enough food to survive. When he comes to a large acacia standing alone in the middle of the river, he pauses. Stripped of its bark, the tree's trunk is nearly naked and its roots exposed from wind, flood and wear. I can't help but think the weathered bull and ancient tree have met many times before—the tree likely has given life to many of his ancestors.

The elephant's trunk sweeps the ground beneath the canopy in search of seed pods. After clearing the ground, he stands on his hind legs with trunk outstretched to reach the highest of available seed pods. He is nourished by the tree and in turn will spread the gift of the ancient acacia.

The dunes of the Namib Desert's famed Sossusvlei are the tallest in the world, cresting heights of more than twelve hundred feet. The area's name is a marriage of the native Bushman tongue and the Afrikaans language: Sossus means a place where water gathers, while vlei is Afrikaans for valley. Several valleys are hidden amongst the dunes: Dead Vlei, Hidden Vlei and the park's namesake, Sossusvlei.

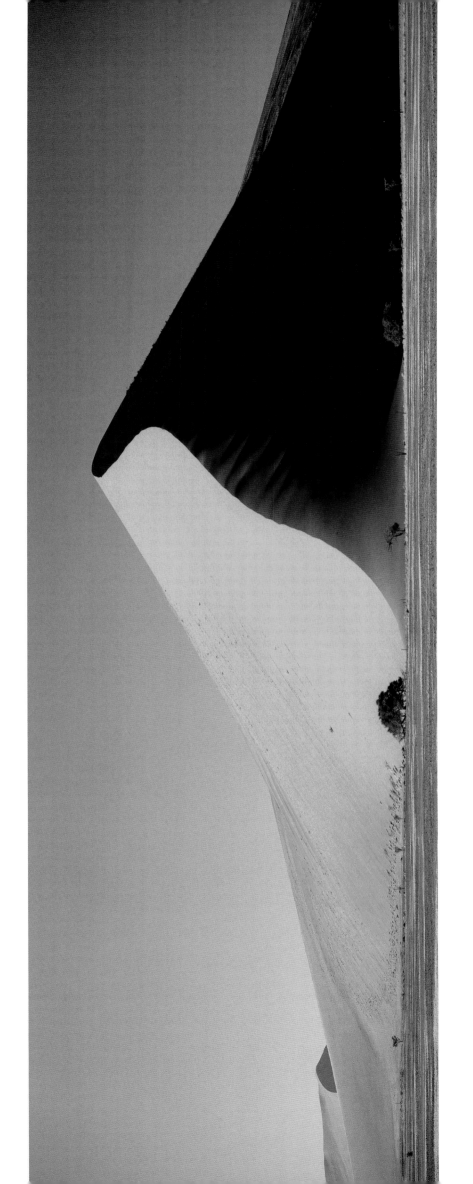

The stark remains of a grove of camelthorn trees mark the Namibian landscape with the abstract shapes of life gone by. The Namib boasts the oldest and driest deserts on Earth, an environment of subtle and extreme beauty.

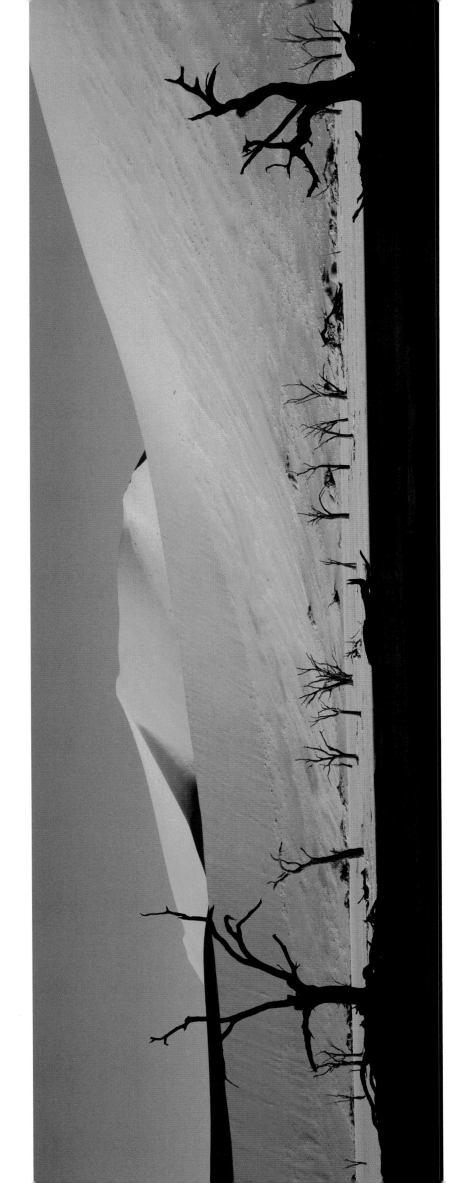

Representing one of just two populations of desert elephants in the world, this lone bull in Damaraland exhibits the adaptations of Africa's well-studied herbivore. The elephants' larger feet and smaller bodies ease the strain of roaming this landscape of loose sands. Local conservancies and neighboring governments are working in cooperation to identify and protect prime elephant corridors throughout this region of the continent, collaborating with landowners to limit damages these herbivores can cause to private property.

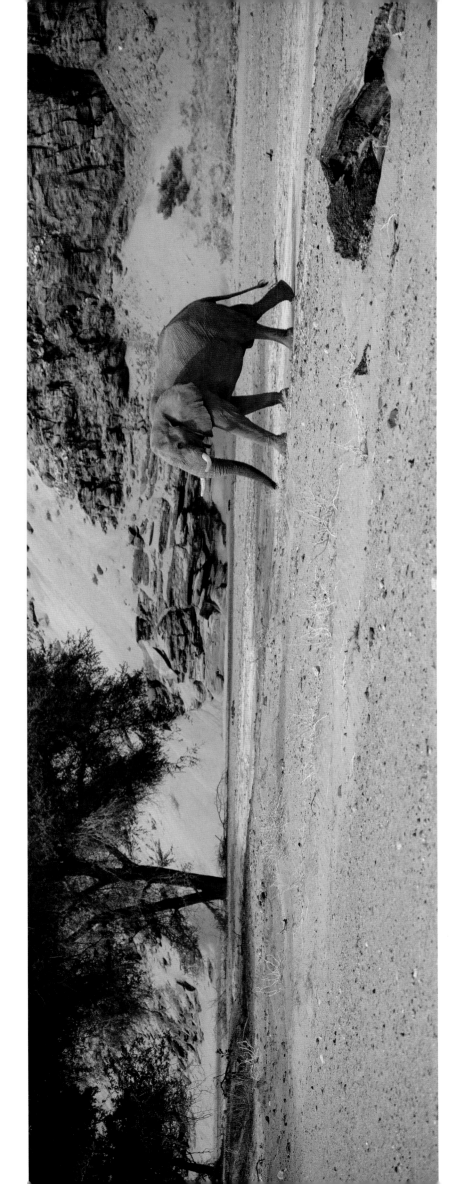

Namibia's native ghost, or phantom, trees are capable of surviving one of the harshest environments on the planet. Frequently seen growing from a rocky precipice, this succulent is a favorite food for desert elephants.

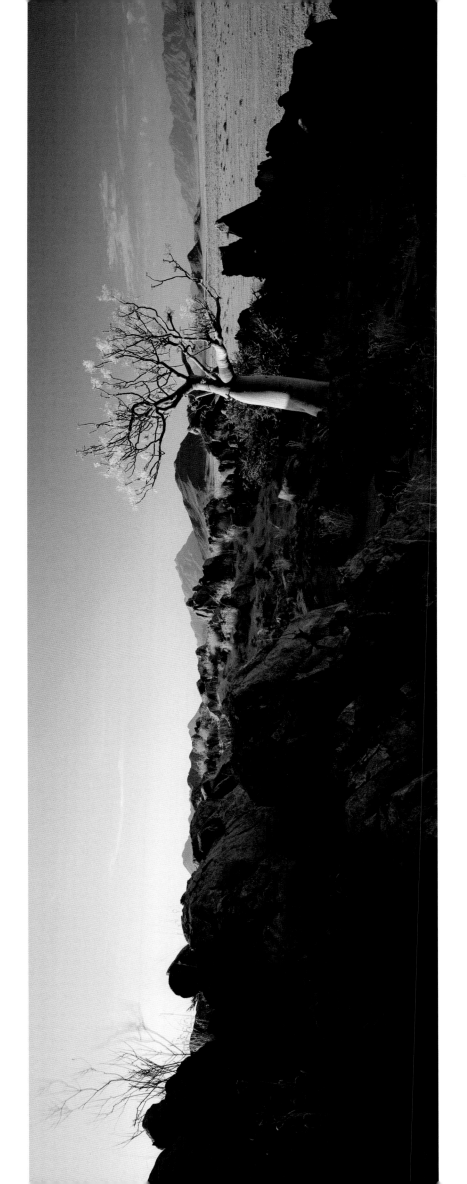

Just as icebergs are defined by the elements—wind, water, the influence of the seas—sand dunes take on myriad formations throughout Namibia's Skeleton Coast. Reversing dunes metamorphose from other forms: linear, dome, star and parabolic dunes; their faces shifting, fanning into wings, spreading out, rising. This landscape of sand is always in flux, forever offering the imagination a new canvas.

Skeleton Coast, Namib Desert, Namibia, February 2003

The vast quiet of this desert is broken by the bizarre and occasional roar of shifting dunes. Researchers theorize that the bellowing sound results from electrostatic discharge between individual grains of sand rubbing against each other, multiplied many times over by the immense size of the dunes.

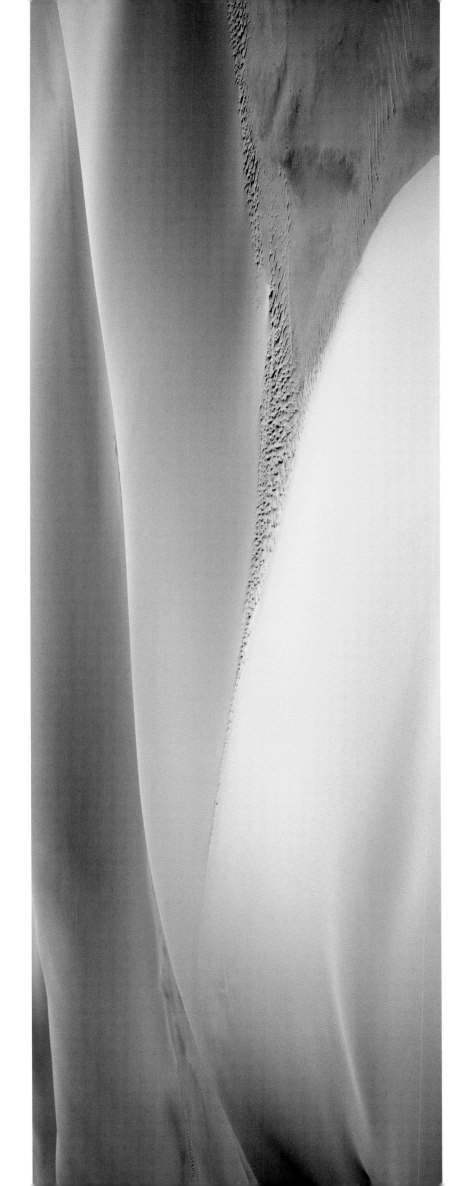

With the sun crawling ever higher into the sky, a gemsbok, or oryx, seeks out the scant shade in a land of few trees. Here, silence reigns. By dawn, he already has quelled his thirst for the day, gleaning moisture from nearby browse. Oryx are known for migrating long distances across the dunes to find the next oasis.

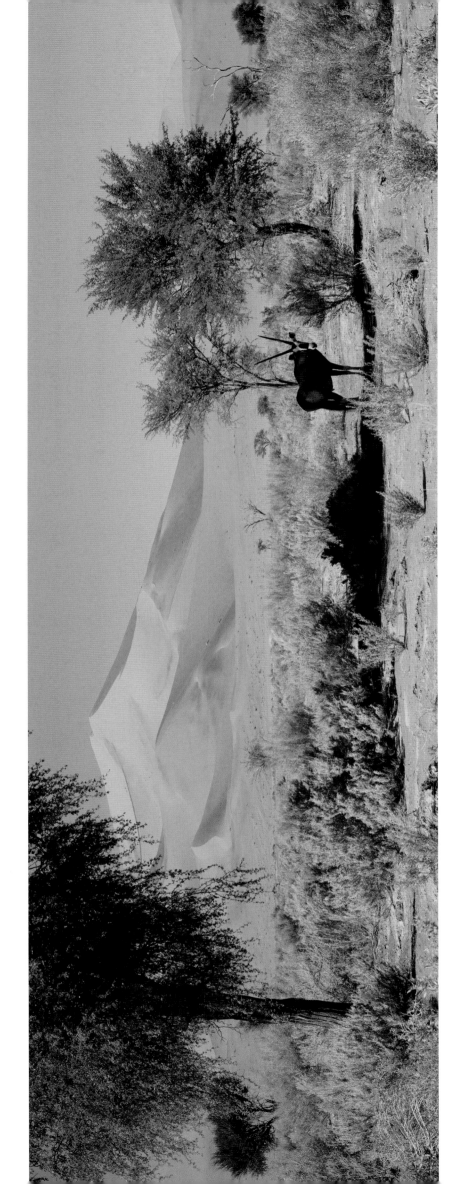

Sossusvlei, Namib-Naukluft Park, Namibia, February 2003

Bearing the silhouette of a kneeling goddess, the withered skeleton of a camelthorn tree—Acacia erioloba—personifies the valley known as Dead Vlei. These dessicated remains are hundreds of years old, relics from the time when a river flowed here freely, unimpeded by Namibia's shifting red sands.

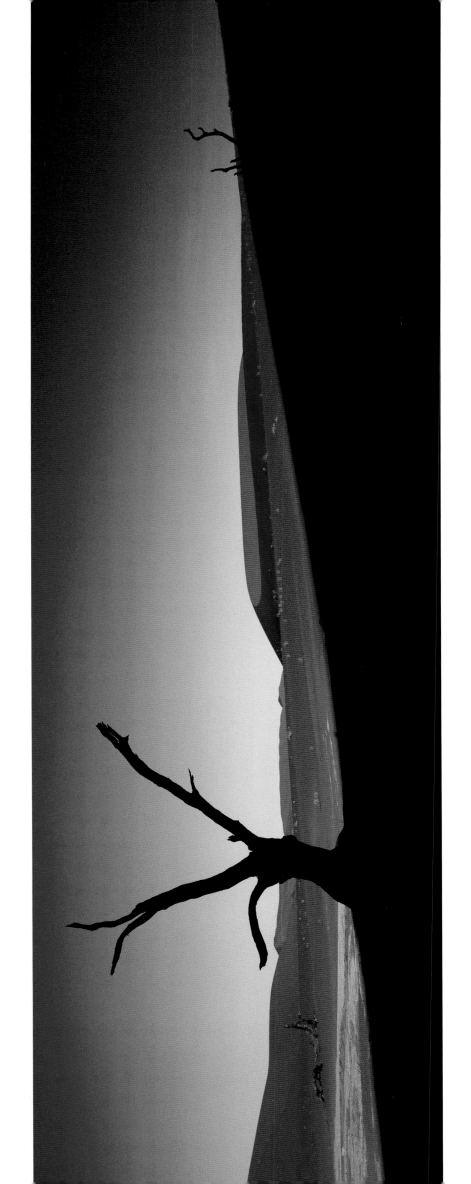

Sossusvlei, Namib-Naukluft Park, Namibia, February 2003

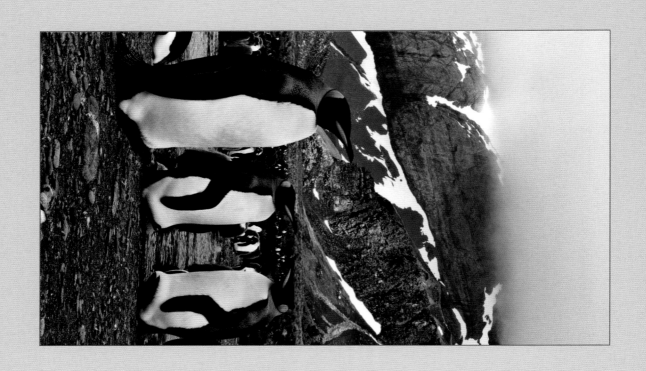

SOUTH GEORGIA
& FALKLANDS

December 2005

A hundred thousand king penguins, along with several hundred fur and elephant seals, greeted us as we landed our Zodiac on the beach at 4:30 a.m. The sky was a pale pink, and the morning looked promising for photography. I had visited Gold Harbour two years ago and remembered it as one of the most spectacular places on Earth. The distant mountain, with its dramatic hanging glacier, is a perfect panoramic backdrop, with penguins and seals as far as the eye can see. Light-mantled sooty albatross and brown skuas rode the onshore winds overhead, while sounds of absolute mayhem in the colony reverberated as the penguins and seals came and went from the sea. The smell was nothing less than overwhelming. It is said that the only scent worse than a dead elephant seal is a live one! I believe it, but was so taken visually by the overall scene that the smell was tolerable.

Snow flurries before daybreak had dusted the green and yellow tussock grass and the hills below the peaks. The temperature hovered around freezing until the sun rose, and soon the snow disappeared.

As the morning warmed, the sounds from the colony of kings and their young, called "oakum boys," grew deafening. I returned to the scene I remembered from the last trip, where the glacial river bent away from the beach. It was nearly the same, but today the light was better, filtered through the moisture-laden air, and this time there were even more penguins standing in the shallow river.

Recalling the images from my earlier trip, I knew my angle had been too high, looking down on the penguins. Needing to get lower, eye level with the birds, I was soon on my belly, lying in all the penguin guano and elephant seal excrement. It didn't matter; my waders and rain gear could be hosed off back on the ship. It is a rare opportunity to be so close to birds that are three feet tall and unafraid and curious about humans. Because I wanted the far mountains, glaciers and the nearest penguins in focus, I needed my lens stopped down to f/45, which required a one-second exposure.

I lay there for two hours, waiting for that single one-second moment when all the penguins lined up and none were moving. Shooting at least ten rolls of film at eight frames each, I hoped that there was a pause in the action when I pushed the cable release. The only distraction, besides the hundreds of moving penguins, was a one hundred and fifty-pound elephant seal pup, a "weaner," that was insisting I was his mother and he was ready to nurse. It was a little disconcerting and difficult to concentrate as the pup nibbled away on my backside. The scene was one of my more challenging attempts with the panoramic camera, and though I knew the image was there, I left Gold Harbour unsure whether or not I had captured it.

Rocking back on their heels, adult king penguins supervise their "oakum boys," the nickname given the young birds by South Georgia's nineteenth-century sealers. With downy feathers resembling frayed hemp rope used to caulk boats, these little ones will spend several months in a nursery school, or crèche, until they head out on their own to sea.

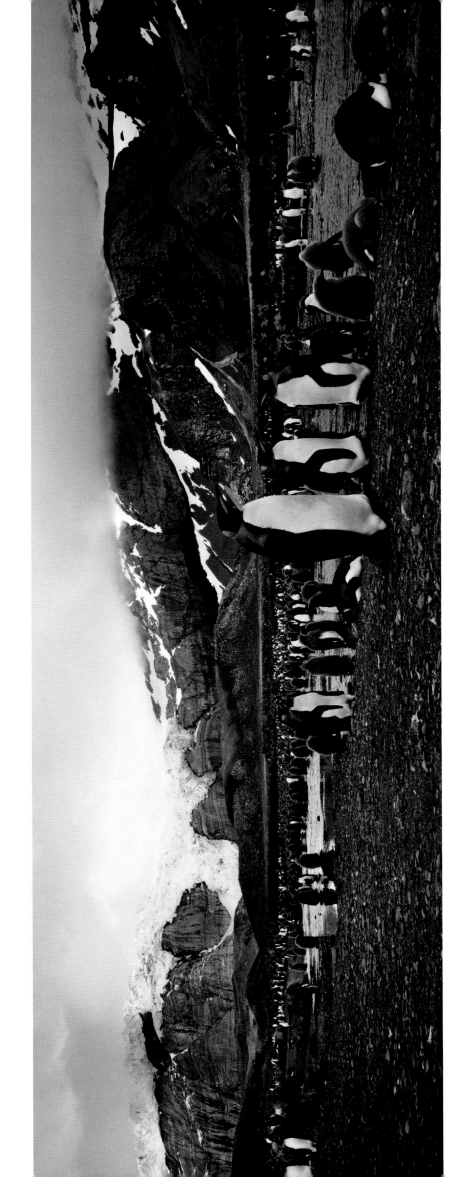

Gold Harbour, South Georgia, December 2005

The moment for the egg pass has arrived. This "make it or break it" exchange for the kings is a delicate dance performed with utter attention and care. Once the female lays her egg, the fifty-five-day incubation will be shared by both partners, each taking turns every six to eighteen days. There is no need for a nest—the single egg is held carefully atop the parents' feet and kept warm by a special fold of skin called a brood patch. After the egg hatches the chick will remain safe on its parents' feet for another thirty to forty days.

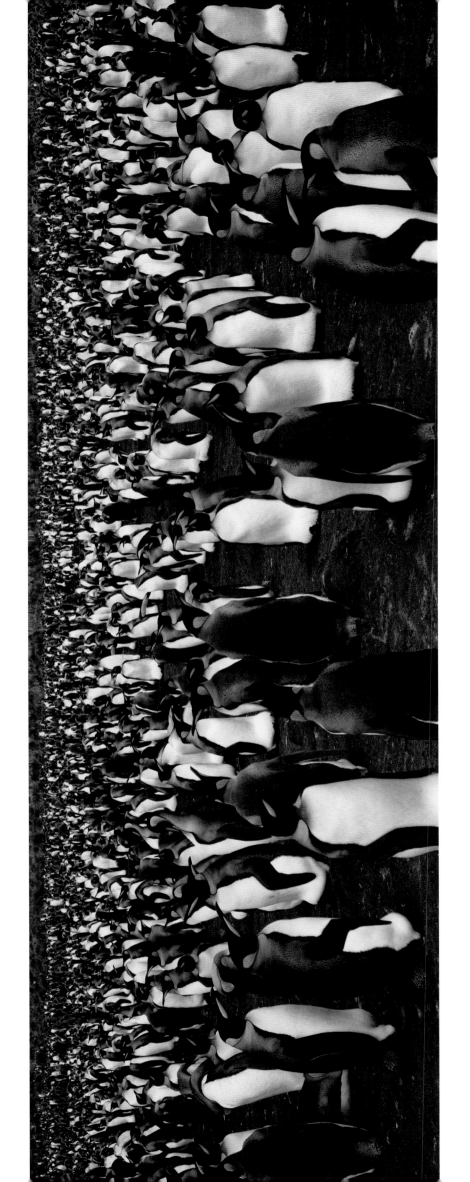

St. Andrews Bay is the gathering place for more than a million king penguins. While emperor penguins take the prize as the largest penguin species, kings come in a close second. A seeming impossibility due to the incredible number of individuals within the colony, parents and young find one another amongst the chaos by the sound of each other's honks and whistles.

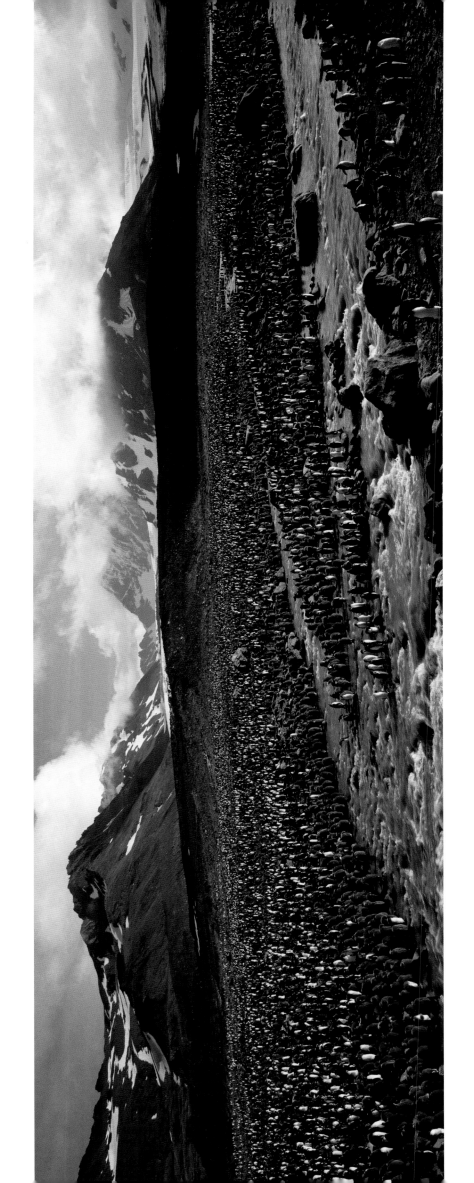

St. Andrews Bay, South Georgia, December 2005

Hordes of fur seals dominate the beach on Prion Island's pebbled shore. Killing the seals for their pelts began in this area around 1786, and by 1831 the seals had been mostly exterminated, according to explorers' records. Over recent decades, with better protection in place, successful breeding seasons have helped these eared seals recolonize former territories, including the grassy hillsides where wandering albatrosses nest and breed.

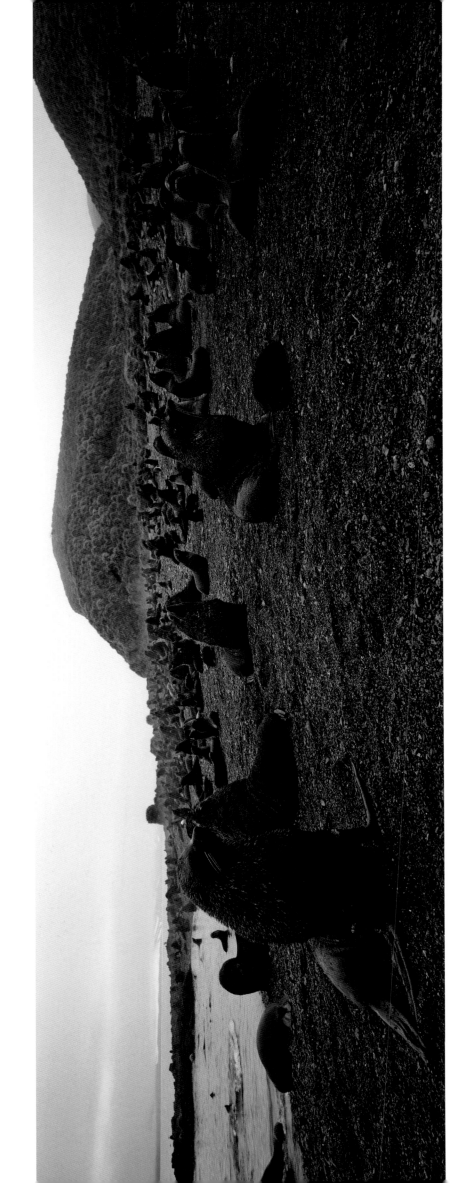

Salisbury Plain boasts one of the greatest concentrations of wildlife in the world and is home to the second-largest king penguin colony. Along the shoreline, many species of marine mammals and birds come and go. Here, a cheeky king penguin faces off with a fur seal, while two adolescent penguins adopt the posture of their neighbor, a young fur seal in repose.

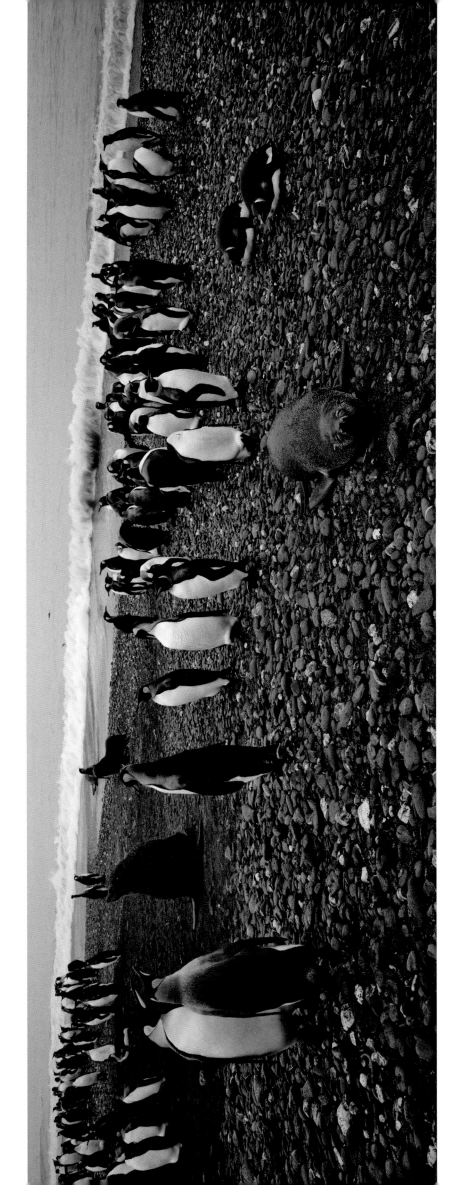

Retreating glaciers on the Island of South Georgia amount to more room for king penguins and their chicks. On the ridge above the heart of the colony, unattached penguins occupy potential nesting sites in hopes of attracting a mate. Their posturing indicates their availability, while their brash calling carries for miles.

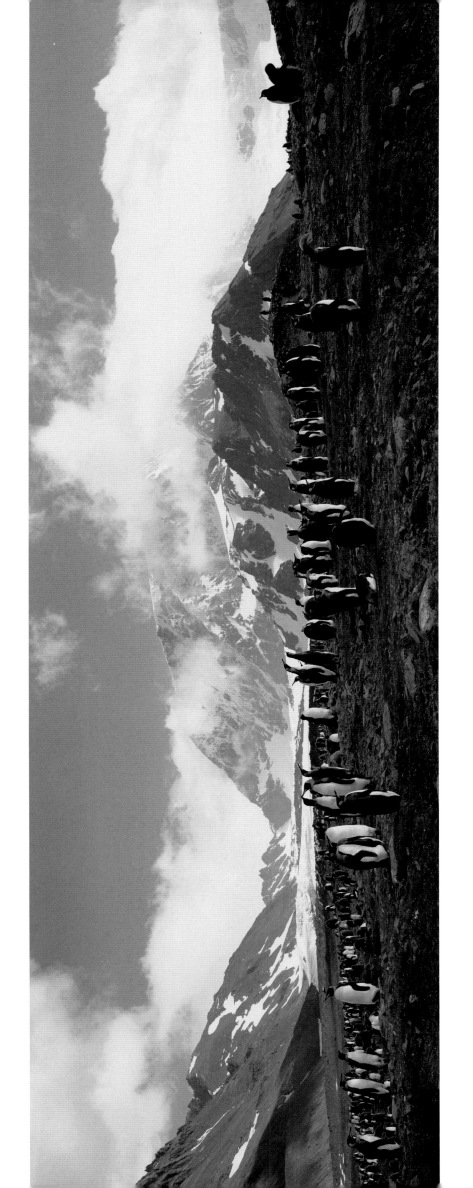

Beachfaring for king penguins means an oceanic excursion into the Southern Hemisphere's most unforgiving waters. This cluster of birds includes males and females who are either returning to their young or heading out to feed. The fledging of chicks coincides with the abundance of food during the summer months, making it easier for the young to survive their first foray out to sea.

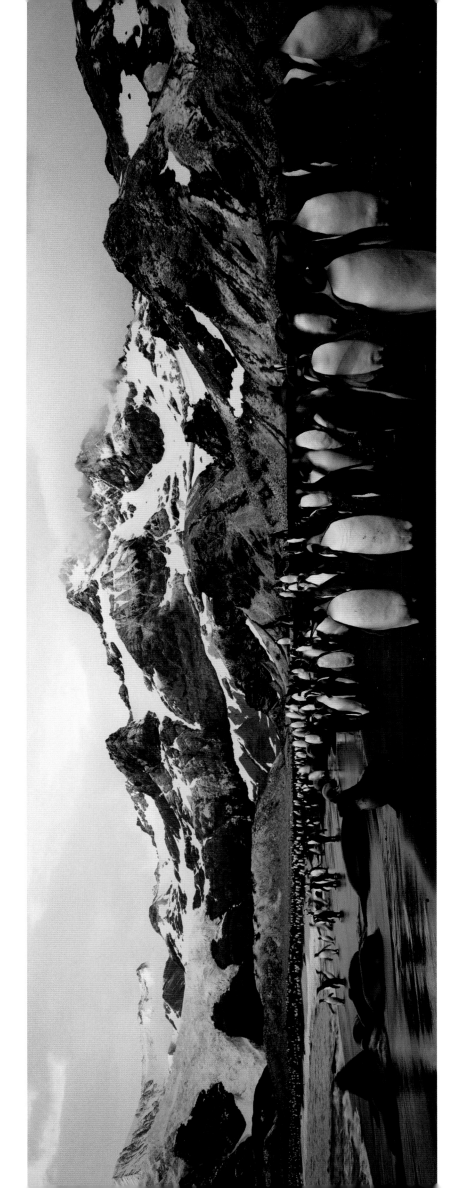

The black-browed albatross exhibits an architecturally rich understanding of nest building, going to great lengths to construct perfect cylindrical pedestals made of earth, guano and tussock grass. These birds are peaceable rookery mates as long as their neighbors don't infringe upon an undefined but well-understood boundary, just shy of five feet.

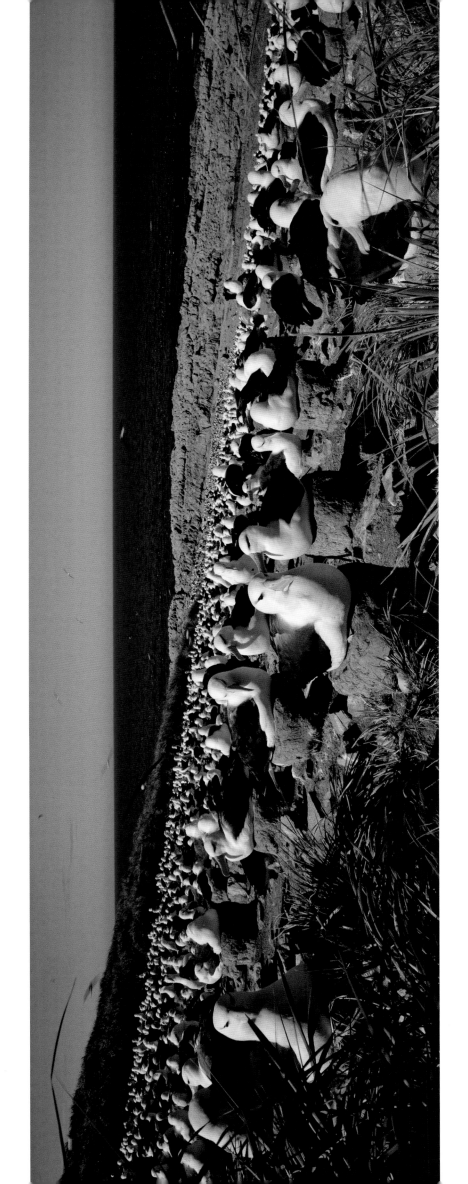

Steeple Jason Island, Falkland Islands, December 2005

Wheeling on an uplift on Steeple Jason Island, a resident black-browed albatross takes to the skies. Soaring above this beachfront colony that stretches over three miles and consists of a half-million individuals, this bird—like all albatrosses—will spend most of its life at sea, returning only to mate and raise its young.

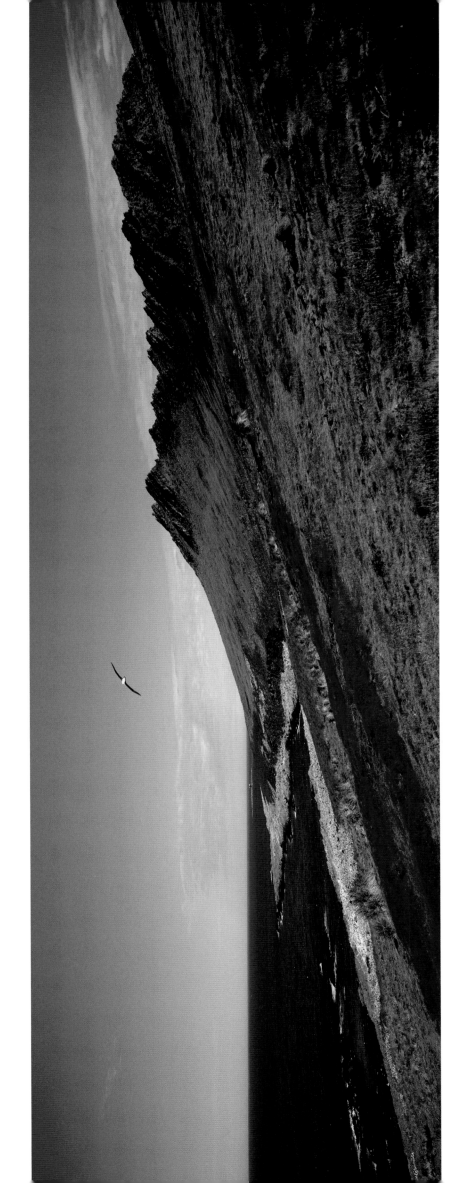

Steeple Jason Island, Falkland Islands, December 2005

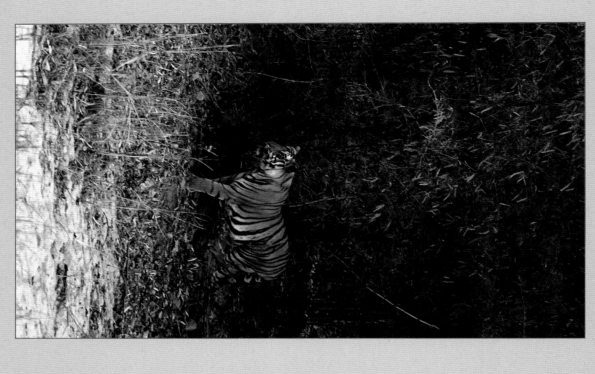

BANDHAVGARH

April 1998

The sharp barks of the chital deer reverberated through the sal forest. From the tops of the highest trees the langur monkeys were frantically whooping. Dhruv, our guide, had one word: "Tiger!" It was not yet 6 a.m., and we already had spotted tiger pug marks in the powder-like sandy road. From the direction of the loudest chital calls we deduced that the tiger was most likely in the meadow, hidden in the tall elephant grass. By the monkeys' behavior—they were keeping an eye on the tiger, bouncing from limb to limb in the forest canopy—we could tell the tiger was on the move, heading in the direction of the blue bull antelope carcass we had heard about yesterday.

Dhruv rounded up the mahout and his elephant, and we climbed aboard. We were searching for the carcass and within a quarter of a mile we found it, led to its whereabouts by the putrid smell of rotting meat. The odor was so overwhelming we had to wet bandanas and tie them over our faces. There we discovered four-year-old Bacchi and her two six-month-old cubs feeding—quite an introduction. Bacchi translates to "girl child" in Hindi, and this particular tiger was honored with the name because she is a daughter of Sita, India's most famous tigress. Like most young tigers in the park, Bacchi and her cubs grew up with elephants and their mahouts—the elephant's drivers and keepers—who patrol the park and protect the tigers from poachers. I was surprised at how close we could approach these magnificent cats while on elephant back; for the most part, they ignored us. Even though the angle from atop an elephant is not ideal for photography, it sure was a great way to see tigers and access a very rugged landscape.

Later in the morning we found a cub from Sita's most recent litter of three, an eighteen-month-old female, lying along the edge of a little creek that winds through the meadow. As the sun rose it highlighted the bright green grasses; the blue sky reflected in the water. A small white-throated kingfisher perched on a nearby branch, eyeing the pool. We had seen many birds—birds as beautiful and as varied as those of East Africa, from peafowl to bee-eaters—and also many species of mammals: mongoose, jungle cat, even a sloth bear, twice! However, the allure of the tiger consumed our attention.

We left the park at 9 a.m. The park is closed to visitors from 9:30 a.m. to 3:30 p.m. This break during the day allows the mahouts to go back to their villages to feed, water and bathe their elephants, who relish the daily ritual. Back at camp we ate a late breakfast, and by noon the temperature soared to 115 degrees. The temperature inside the tent was even hotter. We wrapped our bodies in wet towels and attempted to nap, but there was no escaping the stifling heat.

Heading back into the park after it reopened, we cruised the sand tracks, again looking for pug marks and listening for spotted deer. Once back on the elephant, we spotted Sita's eighteen-month-old male cub, who looked even bigger than Sita and certainly much larger than his sister who we had seen earlier. Soundlessly, he slipped through the elephant grass, heading up into a forest of bamboo. After

momentarily lying down and then changing his mind, he headed down the hill, along its base, just inside the woods.

Trying to gauge his path of travel, we went out onto the dry riverbed, which snaked its way south in the direction the tiger was heading. As we moved farther out onto the sandy wash, he disappeared. We waited, hoping he would reappear; about ten minutes later, he did, pausing at the edge of the forest.

The sun was slipping behind the mountain, its last rays striking the rusty golden leaves of the forest floor, the colors of the tiger. I shot five frames with the 105mm lens. The light was low, 1/30 of a second at f/6.7, wide open. The elephant kept fidgeting—hand holding the 617 at such a slow shutter speed was near impossible under the circumstances. The tiger stood, statue-like, for fifteen seconds or so, every muscle and every sense totally fixed on a small herd of chital who had not yet spotted him. He contemplated his strategy and weighed his chances, then turned slowly into the shadowy forest and disappeared.

It was nearly dark when we headed toward the park's entrance gate and the engine in our Gypsy, a small, open-topped four-wheel-drive, suddenly died. We got out and checked under the hood with a flashlight. Dhruv encouraged us to stay near the vehicle. Fortunately, he is a better mechanic than I, and in twenty minutes we were moving again. The first thing we saw, in less than a mile, were

the burning green eyes of a tiger at the edge of the road. I scrambled to find a camera and, using only the light from the headlights, fired off two or three pathetic snapshots. Not only was it a tiger but Dhruv recognized him as Charger, the dominant and legendary male of Bandhavgarh. He was Sita's mate and had fathered most of the cubs in the park. He had not come by his name casually: Charger has a long history of not only charging elephants but also Gypsys and other vehicles. Barely visible, Charger stared at us for only a brief moment before crossing the road and disappearing into the darkness.

Dappled light plays against a tiger's striped coat, leaving Sita's son all but invisible when seen in his natural setting among the sal and bamboo forests of Bandhavgarh. Now, he dares a cautious first step when leaving the protection of the forest. Survival here is almost always based on anxiety or fear, two emotions that prove crucial in the compromised landscapes where Bengal tigers struggle to exist.

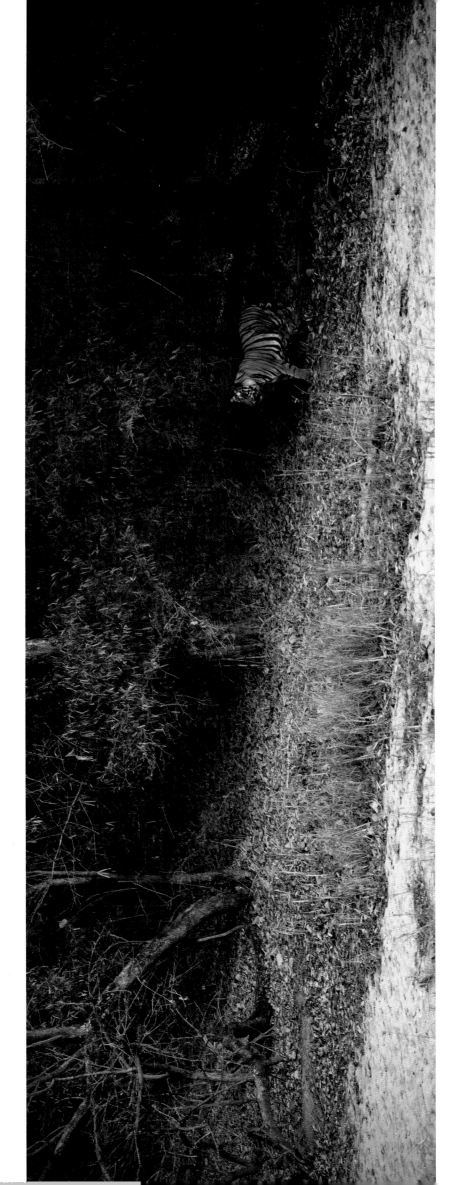

Bandhavgarh National Park, Madya Pradesh, India, May 1998

Central India's Bandhavgarh National Park is a challenged island of refuge for the Bengal tiger. With constant pressure by humans, be they locals gathering firewood around the park's perimeter or poachers capitalizing on the demand for exotic animal parts trafficked through Asia, the Bengal tiger remains endangered. Bandhavgarh is protected, but its surrounding areas and corridor habitats have been fragmented by energy development, dams and mining, further threatening the Bengal tiger.

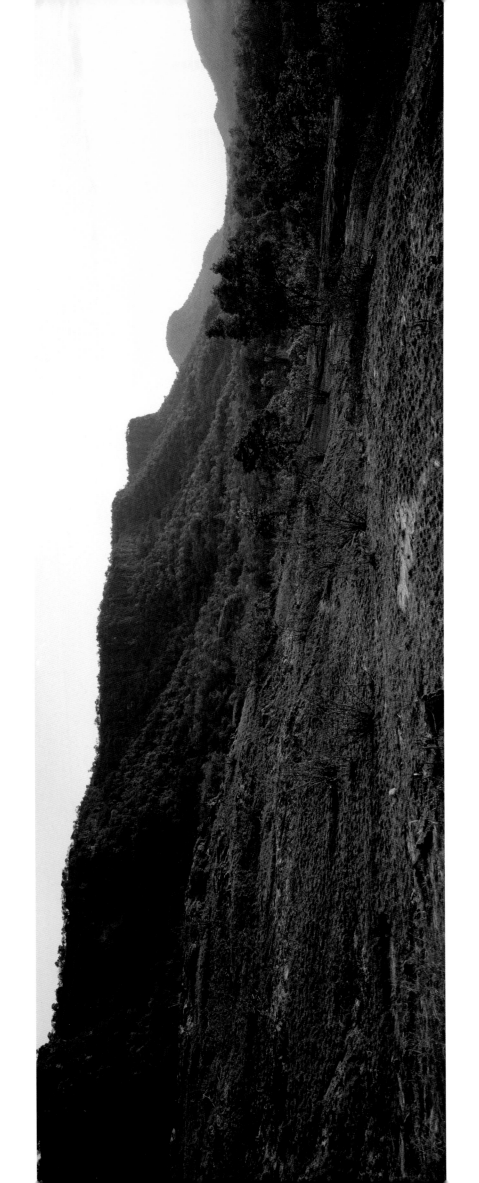

Bandhavgarh National Park, Madya Pradesh, India, May 1998

This male—one of Bacchi's cubs and Sita's grandson—was raised with his siblings in the protected environs of cliff caves, often hidden while their mother hunted the meadows below. As they grow up and vie to stake out territories of their own, tigers often return to these places, a kind of imprinted safe haven recalled from their time as cubs.

A tiger's daily journey includes stops at favored watering holes and stands of shade in the deep elephant grasses of Bandhavgarh's swampy lowlands.

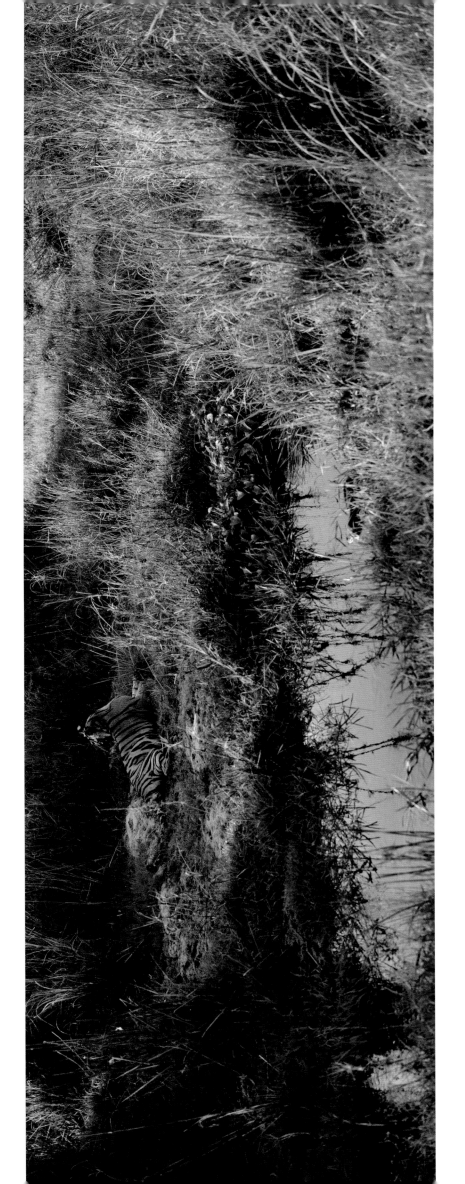

Reluctant to leave his mother, Sita's eighteen-month-old son loafs at her side. Perhaps he lingers to avoid fighting for a territory of his own in the shrinking and highly competitive environment of Bandhavgarh's one hundred and sixty-eight square miles.

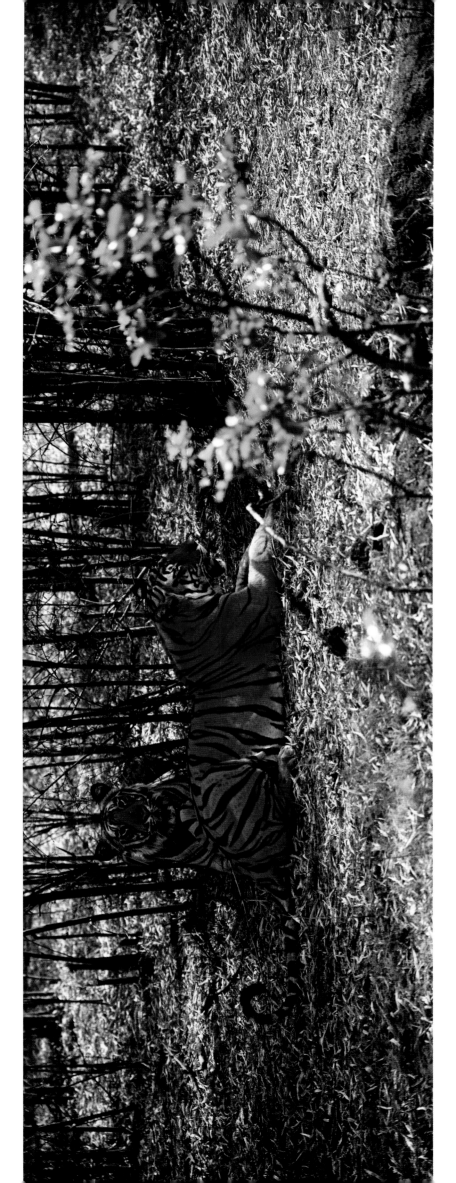

Bandhavgarh National Park, Madya Pradesh, India, May 1998

Water holes are the lifeblood of the jungle, especially when scorching heat takes over much of the Indian subcontinent before the monsoon season hits. All of Bandhavgarh's birds and mammals make use of this water hole throughout the day, timing their visits not to coincide with a tiger lounging in this cool, dark place.

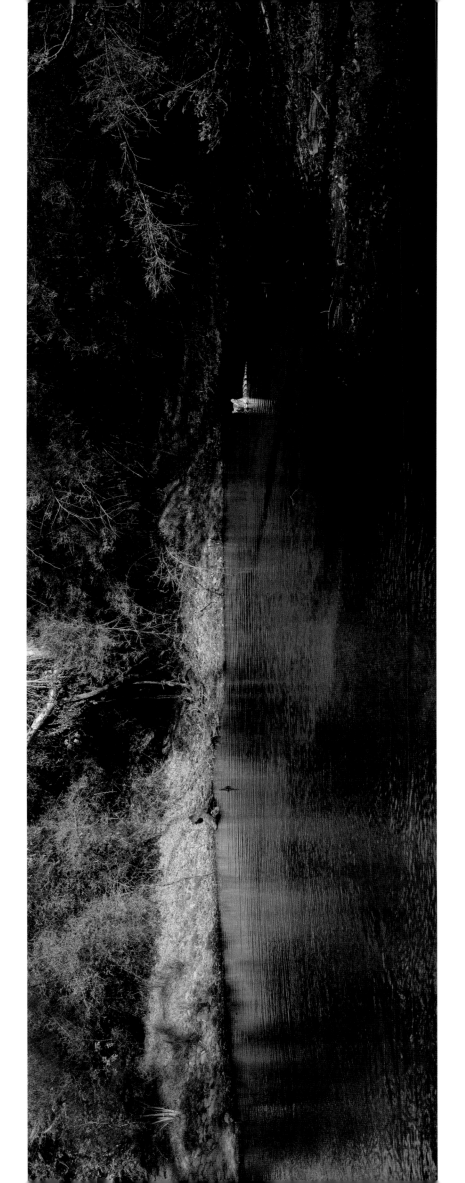

Bandhavgarh National Park, Madya Pradesh, India, May 1998

Her body rigid with anticipation, the tigress Sita considers stalking a herd of spotted deer, or chital, beyond the forest clearing. Langur monkeys clamor among the trees and peafowl caw from above; their racket threatens to undermine her well-rehearsed stealth.

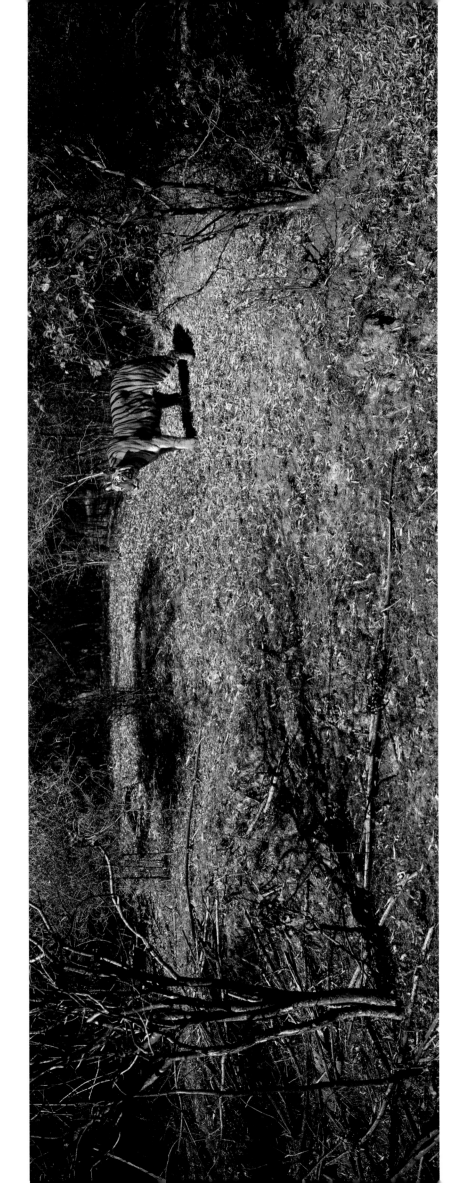

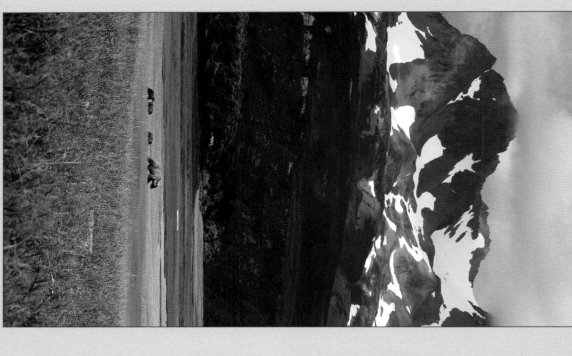

COASTAL ALASKA

June 1998

Lifting off from the Kenai Peninsula, we can see fog and clouds forming on the horizon. The wind has picked up and the plane ride over the open ocean is a bit bumpy. Rocky, spruce-covered islands dot the water below, and the Alaska Peninsula is visible ahead of us with its snow-capped mountain peaks and glaciers pouring down to the sea. We cruise at fifteen hundred feet and within thirty minutes, we are eye to eye with the massive glaciers, our single-engine Beaver dwarfed by the landscape. Surf scoters scatter, gulls and arctic terns wheel in the wind below. A moose wades knee-deep in a pond, and a pair of tundra swans float near their nest. We spot a black wolf walking along the beach, obviously "on a mission." It doesn't get better than this.

The Beaver passes over the bay, circles widely; Dale, our pilot, eyes the waves, checks the wind and heads downward toward the rough water. I have a moment of anxiety, reassessing belatedly the weight of the mountain of gear we have brought. We splash down. Immediately Dale lights his pipe. After catching our breath and glassing the shoreline for bears, excited, we count eleven. We unload our six hundred-plus pounds of equipment into the aluminum skiff and head for the fishing boat, the *Sisbu*, which will be our base for the next two weeks. The protected bay is turquoise, Tahiti-like in color, and surrounded by mountains, with waterfalls spilling down steep, craggy valleys. There are large patches of open areas, devoid of any vegetation, covered in what looks like sand but is actually volcanic ash, evidence from the massive 1912 eruption. The whole

area, known as The Ten Thousand Smokes, was buried in ash. Today, eighty-six years later, most of the mountains' lower elevations are covered in alder bush and devil's club, a most appropriate name for a plant: The undersides of their maple-shaped leaves are covered in tiny, skin-irritating needles with intertwining stalks—totally impenetrable to humans.

On our two-hour flight from the mainland we counted nearly fifty brown bears. Some were in the rivers feeding on salmon, others on the coastal sedges, grazing, and some out on the tidal mud flats digging clams and picking through the blue-grey mussel beds. It's a time of feasting for these giant coastal bears and a place where all food groups are fulfilled and even the pickiest of a bear's taste buds are satisfied. The feast starts with a bit of sedge salad in the afternoon when the tide is in, followed by a dinner of salmon—pink, chum or the "Catch of the Day," the glorious red sockeye—then finishes with a dessert of mussels and clams. It's a good life for bears during these bountiful but short-lived summer days. Not only will their appetites be satiated, but they will take in the enormous amounts of fat and protein they need to survive the long, frigid Alaskan winter. The bounty is especially important to mothers with cubs.

We finish unloading our gear, have a quick cup of coffee and take the skiff out to look for bears. There is a bit of coastal fog filtering the light, adding a moody softness to the land. Two hundred yards from our boat we spot a reddish female bear with her yearling triplet cubs in tow, digging clams. We approach slowly and from upwind so they can catch our scent, then shut down the motor and pole the boat quietly along the shore to give them time to get accustomed to our presence. They are wary, but not threatened, and continue digging. Pouncing up and down on the sand with their front paws, the bears dislodge the likely suspects. With massive canines, they crack open the shell, and with a surgeon's precision they remove the tasty morsels with long, razor-sharp claws.

These bears see few people other than the odd halibut, salmon or crab fisherman. Mothers with cubs are generally the most cautious, especially if there are male bears around who will sometimes kill cubs. Older bears—those who have survived the poaching and trophy hunters who come into these waters in the fall—are also wary.

It's a sort of schizoid life for a bear in Alaska. One month there are people with fishing rods, photographers with telephoto lenses and bear watchers with binoculars; the next month it's bear hunters with high-powered rifles. Unfortunately, the State of Alaska allows trophy hunters to kill more than two thousand grizzlies every year, more grizzlies than inhabit the entire lower forty-eight United States. Sadly, some people are more drawn to a dead and stuffed "trophy bear" than to appreciating, and leaving behind, a living, breathing bear on a wild salmon stream.

We continue to pole the boat slowly and quietly: I get out of the skiff in chest waders and set up the tripod in three feet of water while the family continues to dig for clams. The mother looks up several times as I click the shutter. It is a tranquil scene with a light rain falling.

The bears are feeding in front of a small, alder-covered island, perfectly framed by snow-covered peaks, and soon the cubs grow impatient and start bawling at their mother, a call to nurse. Their calls grow louder and louder until finally the mother wheels around and snaps at the one clinging to her rump. After the scolding, the family walks together through the saddle of land between the islands, disappearing from sight. Obviously, mom was not yet in the mood to nurse. She is not a particularly large female, and the cubs seem a bit thin and gangly. It must be challenging and very physically demanding to raise three yearling cubs.

Back in the skiff, we round the island and head toward the *Sisku* for our own dinner of fresh king crab and salmon. Looking back at the island, I envision the bear family snuggled out of the rain under a thick cover of alder, the cubs finally getting their way.

Coastal sedges tempt a family of brown bears out of the alder forest to graze and wait for the arrival of the salmon run. Glacier-covered mountains crown the backdrop of one of the Alaska Peninsula's spectacular wild places. Driftwood, carried ashore by strong Pacific tides, becomes a permanent addition to this windblown, virgin landscape.

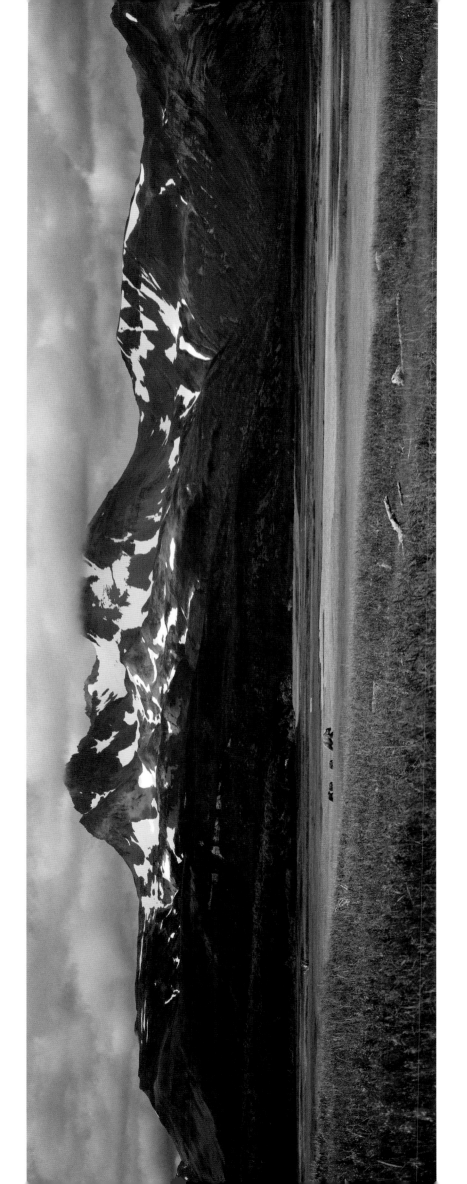

Summer on the Alaska Peninsula: By mid-July, the sedge flats and mountainsides of the Alaska Range are set ablaze with blooming fireweed. The Alaska Peninsula is situated in the heart of the Pacific Ring of Fire, the most active band of volcanoes in the world.

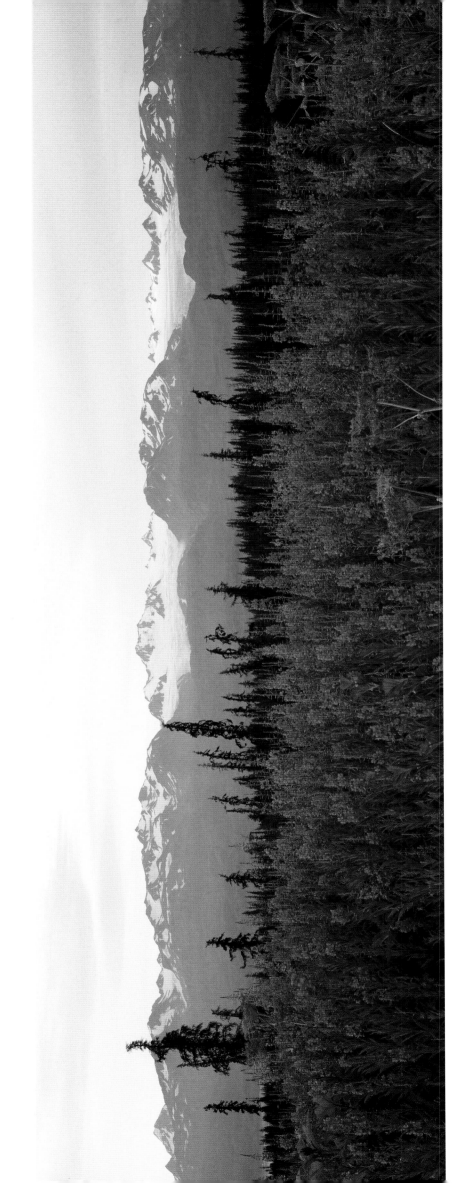

As early-morning fog lifts from the tidal flats, a family of brown bears uncovers the bounty left by retreating waters. Clams are a favorite food of *Ursus arctos* and are plentiful this time of year. Once the bears locate a clam under the sand, they pounce on it with their front paws to crack the shell, or dig up the clam and gently pry it open with one of their prodigious but surprisingly agile claws.

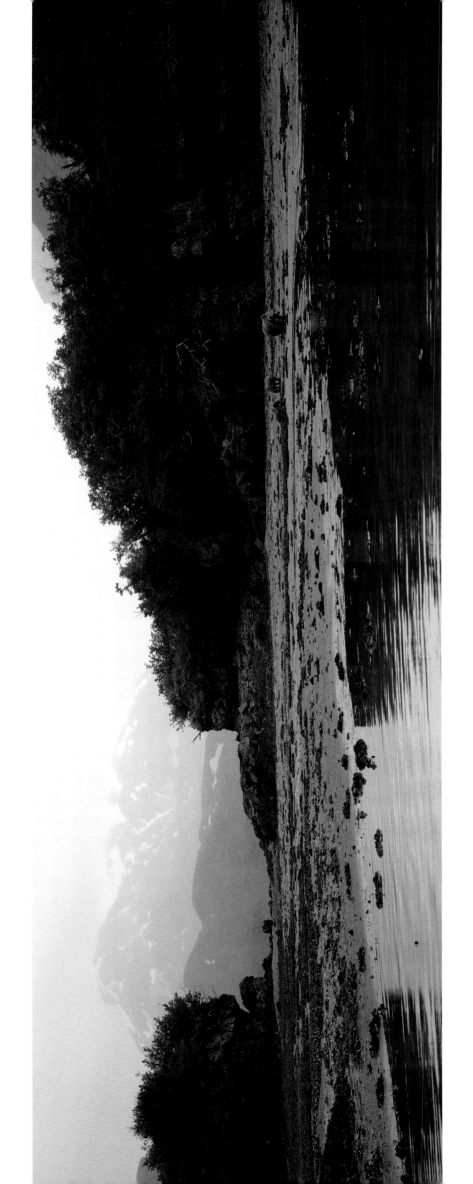

All that is left of the summer's spawn are the dessicated remains of a sockeye salmon. Completing his mission upstream means that this voyager was successful in finishing his life cycle. Next year, another group of sockeye will make their bid to the great river lords.

Stepsister to the rainbow, a sundog materializes at day's end over an old-growth forest of Sitka spruce and western hemlock on Chatham Strait. Orcas and humpback whales ply the waters here, also home to sea lions, otters and Dahl's porpoises. Deep in the forest black bears and grizzlies roam, the hermit thrush singing its flute-like song.

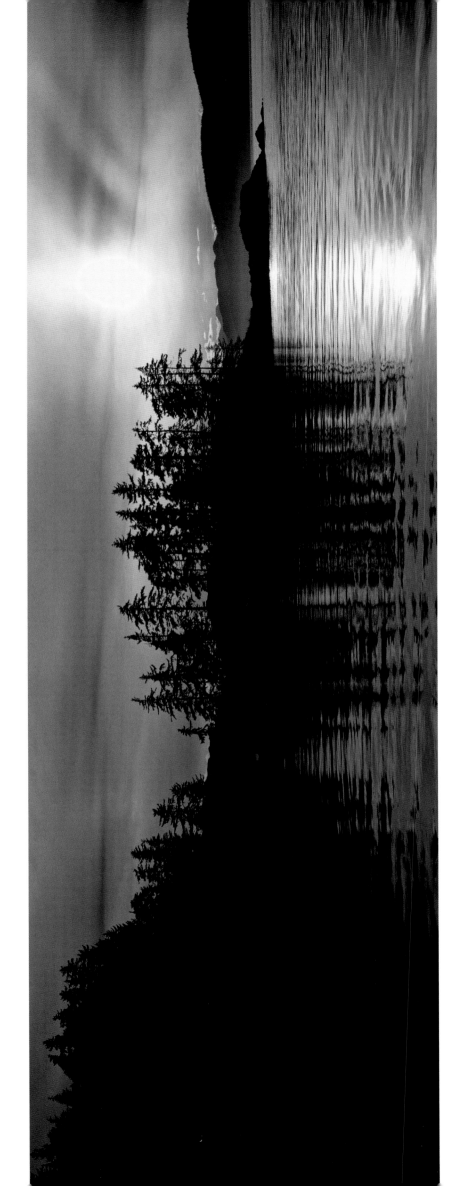

Researchers hypothesize that humpback whales breach to communicate their location to other whales, and that the activity, also seen as a form of play, may cause an impact powerful enough to dislodge irritating barnacles from the whale's skin. This particular humpback breached more than fifty times in ninety minutes.

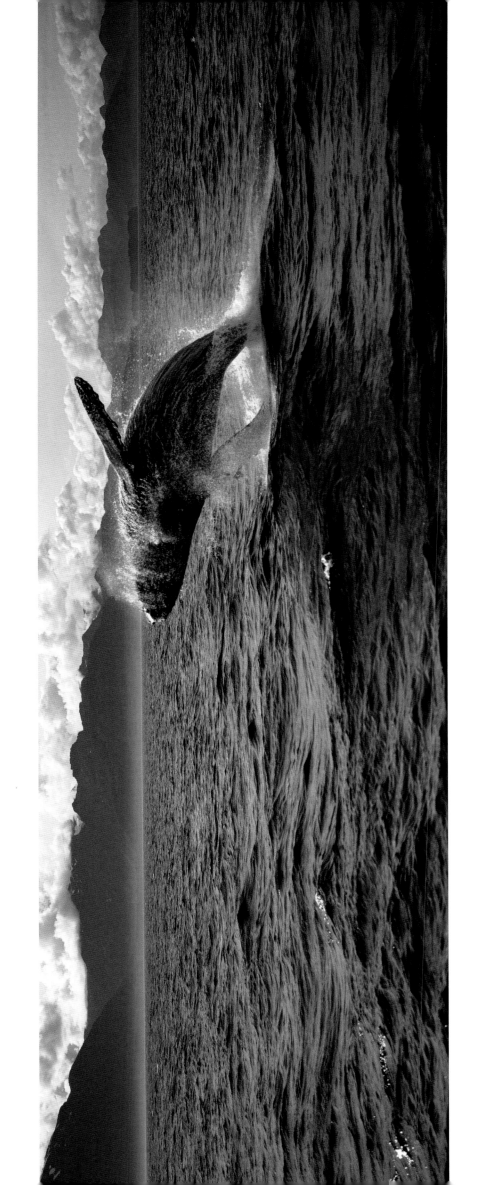

Chatham Strait, Southeast Alaska, USA, August 1995

Eerily beautiful and seemingly out of place, a jagged chunk of glacial ice thirty feet tall is stranded on a coastal tidal flat, likely beached during an outgoing tide.

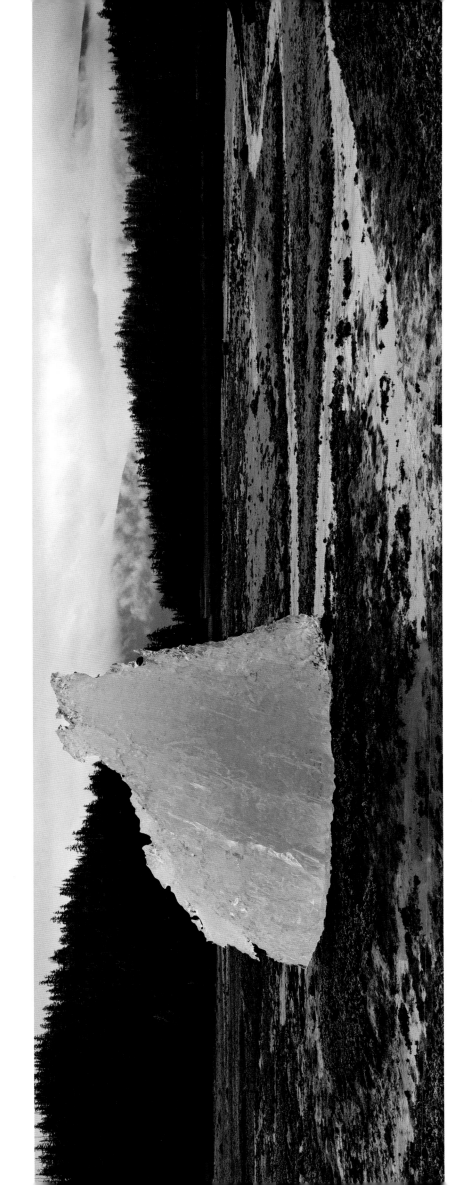

Comprised mostly of males—note the humped backs and hooked jaws—a
school of "reds" follows their instinctual drive to undertake the fiercest and
final journey of their lives. After spending up to four years in the salt waters
of the Bering Sea, some journeying more than a thousand miles, the fish
return to their birthplace in preparation for spawning. As the ritual draws
near, the once dime-bright salmon turn a brilliant red.

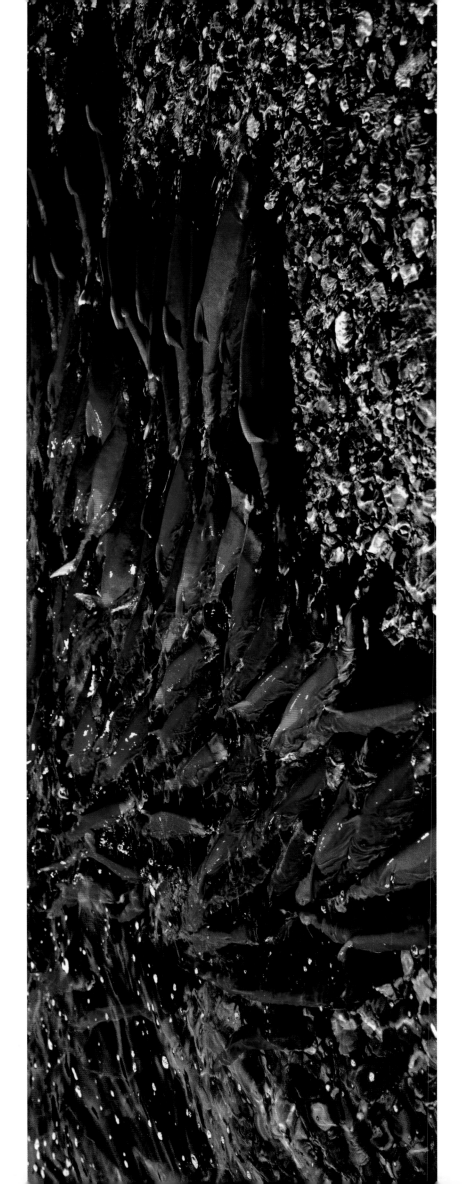

Funnel Creek, Alaska Peninsula, Alaska, USA, August 2003

A bald eagle searches for materials as he begins the yearly task of nest building and reconstruction. Instead of starting from scratch, eagles add material to sites from previous years, and these nests can grow to an average diameter of seven feet. Built from sticks and branches and lined with grasses, the nests make for a comfortable sanctuary.

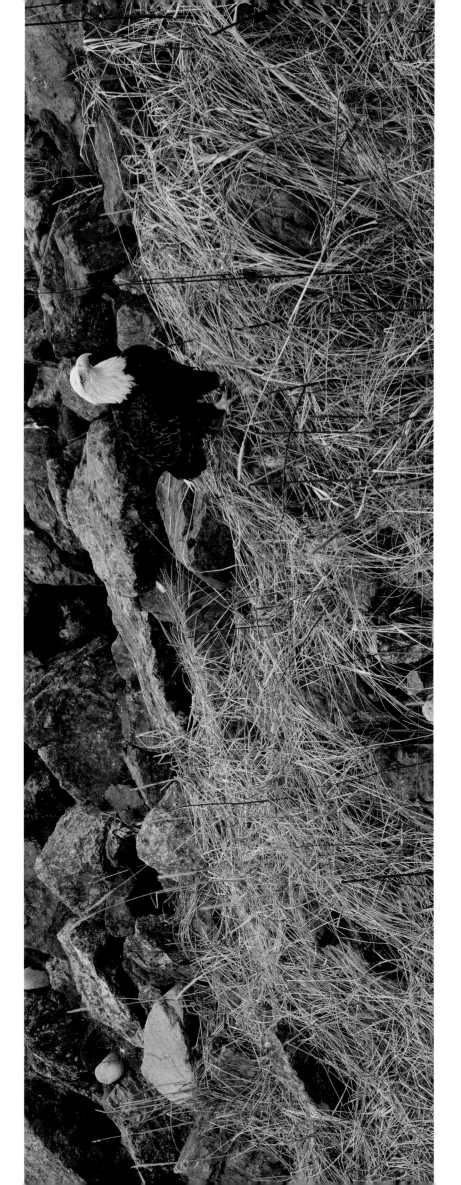

A chunk of granite appears to have tumbled from the spine of the Alaska Peninsula, dwarfing a hefty brown bear who scavenges the shore. When the tide drops, brown bears emerge from the tangle of alder thickets at the base of the uplands to dig for clams and barnacles along the beach.

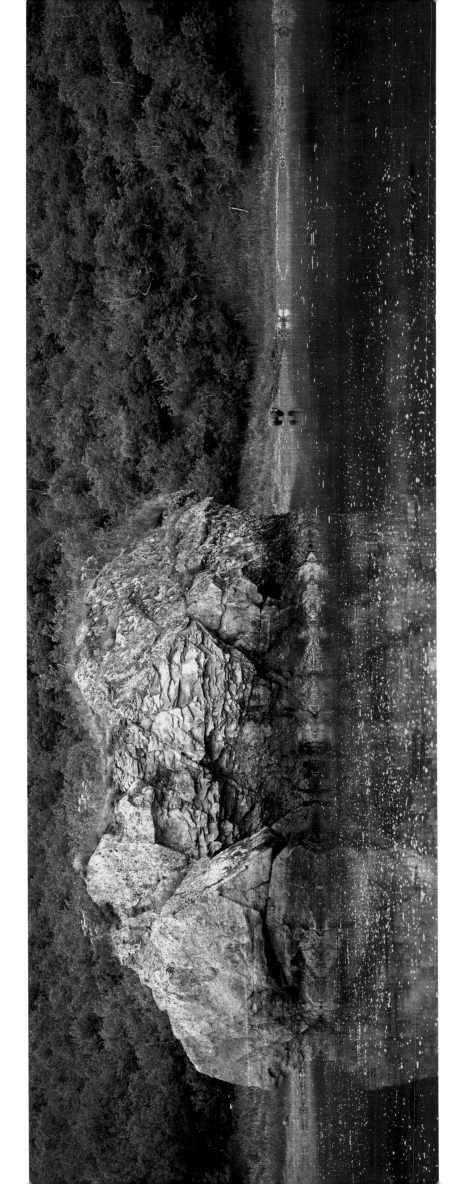

By late December only a few hours of sunlight reach the frozen landscape of the Chilkat Valley in southeast Alaska, where a pair of bald eagles shares a roosting place in a bare cottonwood tree along the river's edge. Below the cottonwoods and evergreens the Chilkat still flows, kept open by thermal springs deep within the earth.

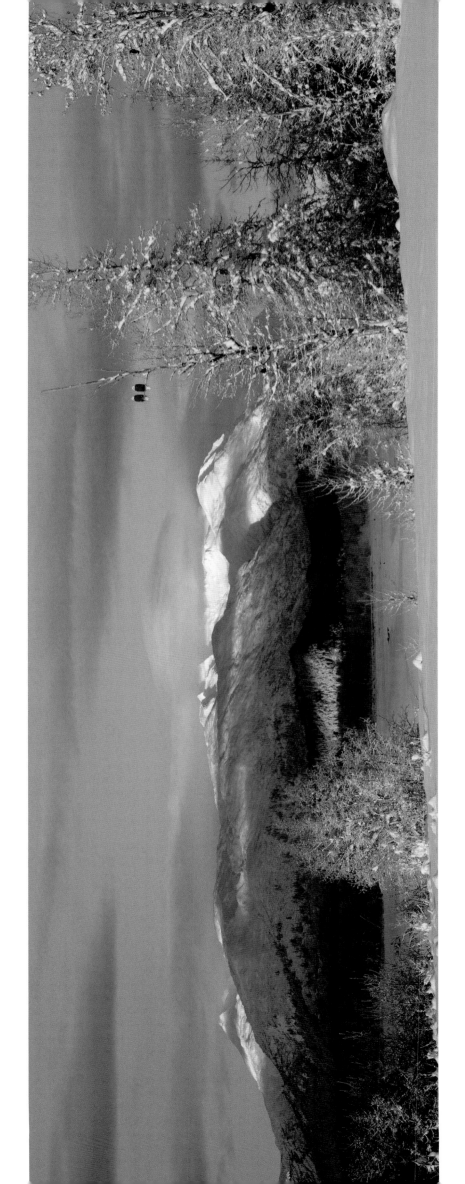

Chilkat Valley, Southeast Alaska, USA, December 2001

117

A lone ambler, a coastal brown bear ghosts across a ridge above the Shelikof Strait. Hidden behind the clouds lies Mount Katmai, a six thousand-foot active volcano that crowns one of Alaska's best-known areas for brown bears.

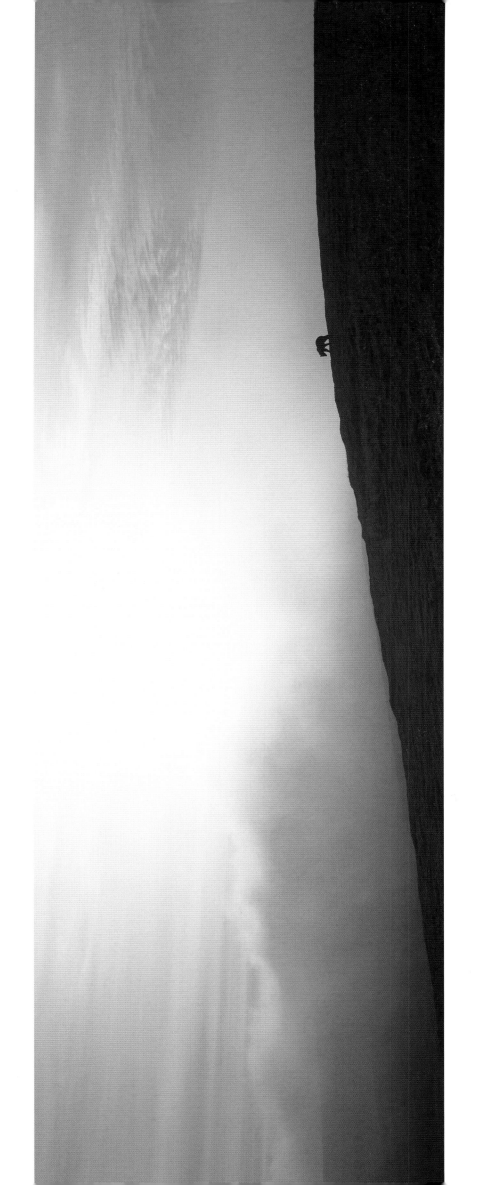

Bald eagles are typically rivals when it comes to food, but tonight along the coast, a straggling piece of driftwood makes the perfect sunset perch for a pair of birds who have fished their last salmon of the day. Tomorrow, the competition will begin anew.

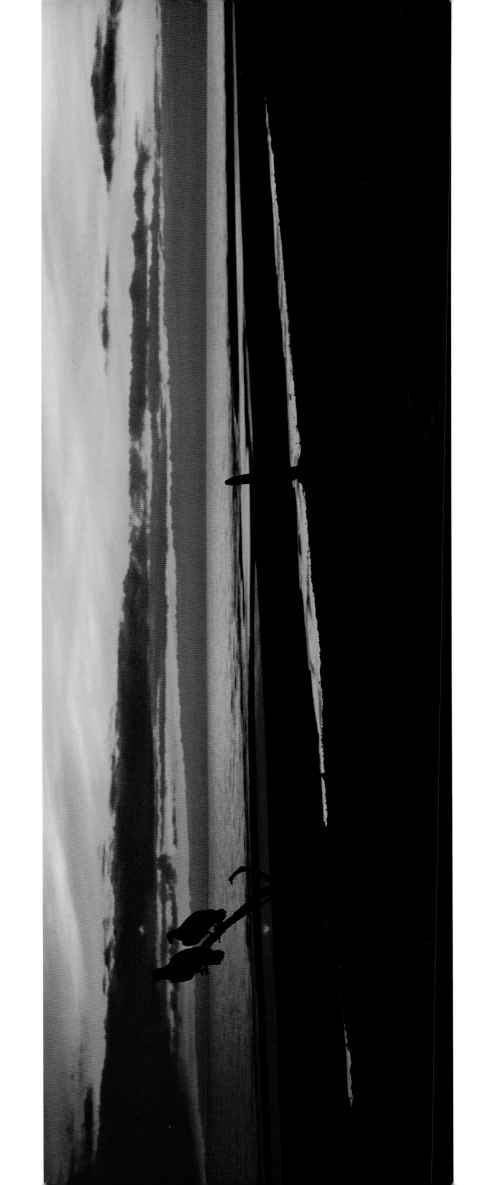

Kachemak Bay, Kenai Peninsula, Alaska, USA, March 2000

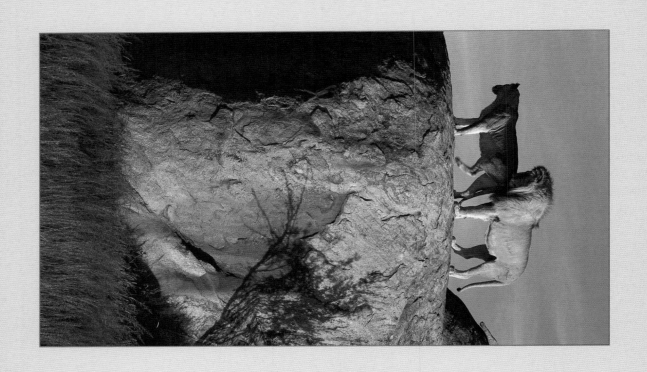

SERENGETI & NGORONGORO

February 2002

As we drove across the Serengeti toward camp, the sun was setting, its orange glow heightened by the dust in the air and the smoke of distant Maasai fires. Wildebeest were spread out thickly across the shortgrass plain. Thompson's gazelles pronked as we drove by, and a small herd of impala, gathered near the edge of a brushy woodland, raised their heads. The glow of a campfire greeted us as we followed the narrow, dusty track down to our tents near the lake. Sitting by the fire after cocktails and dinner, we watched the full moon rise and listened to the low moaning grunts of wildebeest on the move. Lions roared in the distance. During the night we were comforted by the sounds of crickets and frogs, yet restless from the melancholy whooping of hyenas.

At daybreak we awoke to the soft calls of mourning doves and left camp at 6 a.m. We stopped to photograph the acacia trees and a few hundred flamingos, abdim storks and red-billed teal on the lake, but no mammals. Nickson, our guide, said he had seen a lot of wildebeest crossing the lake six days earlier. All I could think of was Hugo von Lawick's films about the Serengeti and his footage of the wildebeest crossing the lake at sunrise. Hugo, the late husband of Jane Goodall,

was one of the best wildlife photographers and filmmakers who ever lived. Jane and Hugo's books and films had a huge influence on me and are one of the major reasons I started taking pictures of wildlife. Hugo had a camp for 25 years only a few miles from our campsite. I wish I could have gotten to know him better, but his spirit will always be in this place.

After photographing the sunrise we drove down to the lake. About seventy-five yards above the shoreline was a family of five bat-eared foxes, four lying in a pile to keep warm, and the fifth lying near the den. Farther on, several dozen greater flamingos were gathered closely together, feeding on algae near shore. They paid little attention to us in their feeding frenzy, swinging their heads and large bills through the pea soup-like water, filtering out the algae. Cattle egrets, stilts and plovers worked the mudflat.

Afterward, we broke out breakfast—hard-boiled eggs, toast, little sausages, coffee and Milo—spread it out on the hood of the Land Rover and continued to watch the flamingos and all the goings-on. Fortunately, the smell of the coffee masked the fishy smell of the lake! After our break we continued on to Lake Masek, a couple miles south.

The bleached skulls and bones of wildebeest littered the shoreline. Twenty yards above the water's edge tall grasses grew, easily hiding lions or leopards. One skull in particular attracted my attention—the waves were lapping at the shore, and the soda foam made undulating white patterns complementing the white skull.

I had only shot a few frames before we heard the thunder of hooves. Behind us tens of thousands of wildebeest were stampeding through the forest down to the lake, great clouds of dust rising all around. We packed up the vehicle quickly and drove across the mudflat for a closer look. A never-ending stream of wildebeest poured through the forest, the ones in front flooding ahead, moving farther down the opposite shore. It was one of those "blue ribbon" moments. As soon as the wildebeest watered, which took only ten to fifteen minutes, they turned back, not stampeding, but in long, sinuous lines, moving toward Lake Ndutu.

It is said that no one visits Africa only once.

Kopjes—pronounced "copies"—stipple the Serengeti landscape and give resident predators another leg up on their prey. This ruling male lion uses the outcroppings to monitor the approach of any competitors for his pride of females. He will spend hours mating with this lioness; by continually repeating the act, the male ensures his seed will take root.

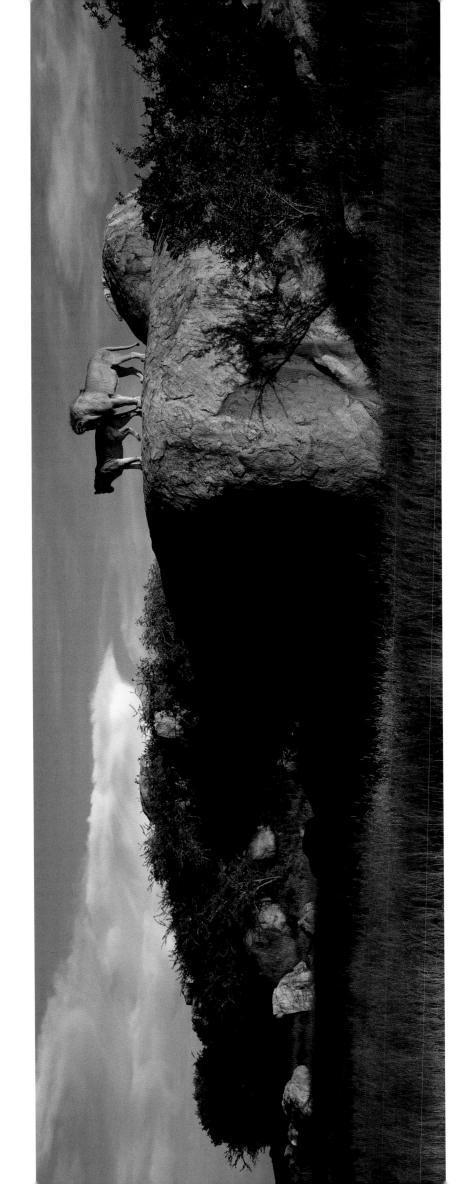

Part of the East African Rift Tableau, the Ngorongoro Conservation Area is a massive crater bordering the eastern edge of the asymmetrical crescent of Serengeti National Park. Ringed with walls that are two thousand feet high, the crater forms a natural enclosure for resident populations of wildebeest and the array of predators that benefit from more than enough prey. Lake Makat lies almost in the center of the basin, too alkaline for most animals to drink.

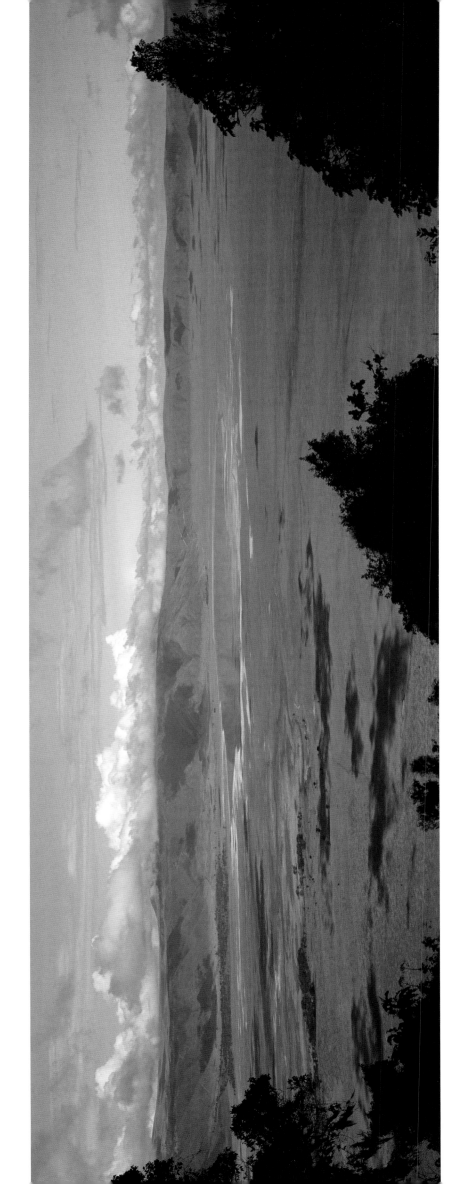

Ngorongoro Crater, Ngorongoro Conservation Area, Tanzania, February 2002

Lake Ndutu is on the annual migration route for thousands of wildebeest and zebra. The vast herds will spend their mornings grazing the shortgrass plains nearby and retreat to the shade of the accacia forests during the heat of the day.

Likely a victim of a pride of lions stalking the grasses that edge Lake Masek, a wildebeest's skull symbolizes the constant tension between life and death on the Serengeti. Distracted by extreme thirst and overwhelmed by the opportunity to finally drink, wildebeest often lapse from their state of heightened alert, resulting in a victory for any predator that may be near.

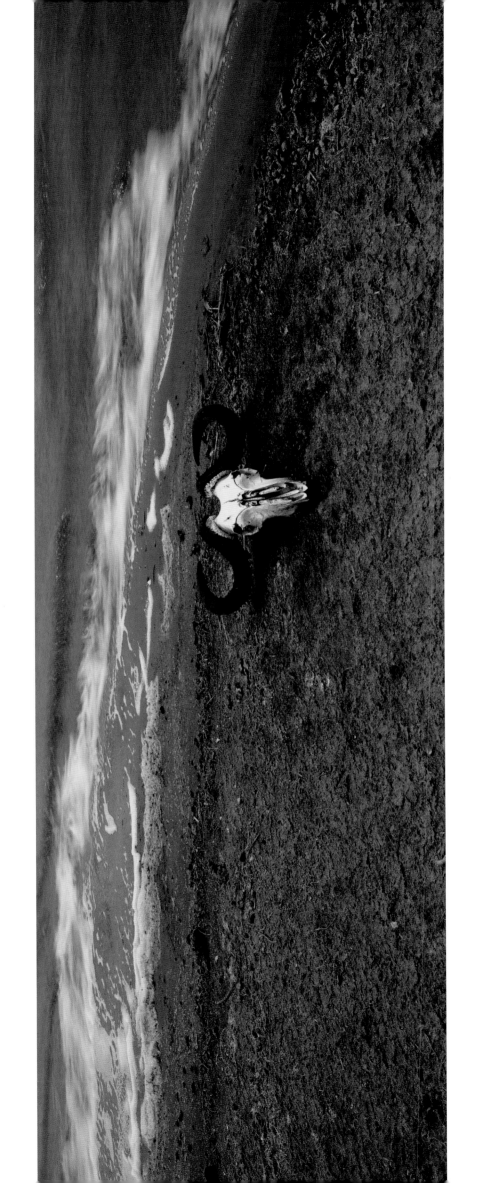

131 Lake Masek, Serengeti National Park, Tanzania, February 2002

A tricolored band of avian life only begins to illustrate the diversity of birds found in the Serengeti. Flamingos are common along the lake, and the white cattle egret equally so, both here and on the plains. But the blacksmith plover, armed with spurred wings, keeps to his reputation as territorial and a solitary nester.

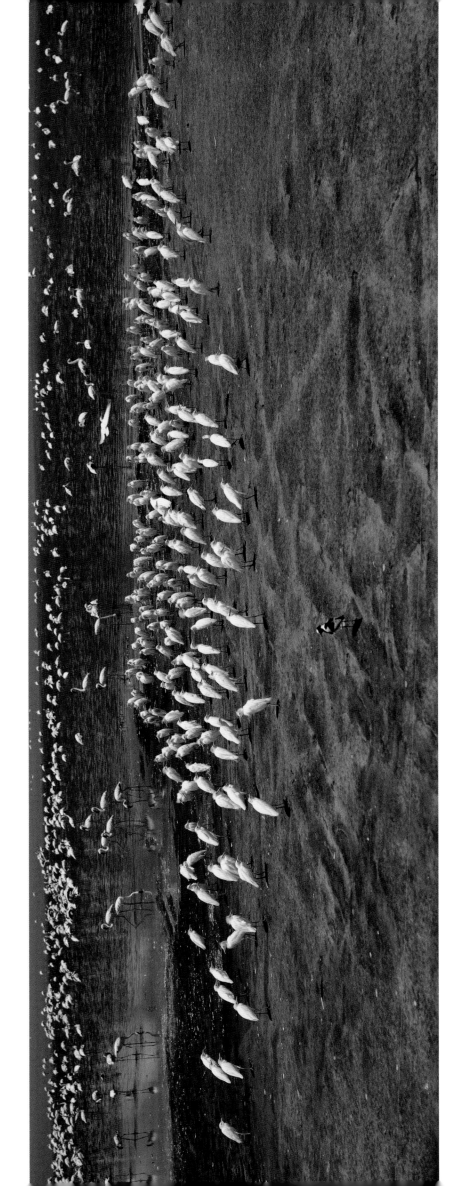

Lake Makat, Ngorongoro Conservation Area, Tanzania, February 2002

Cattle egrets blur in flight, following the herds that make their pilgrimage across the floor of the Ngorongoro Crater. Hundreds of thousands of hooves rustle insects in the grasses, creating a flying bonanza the egrets will feed on at every opportunity.

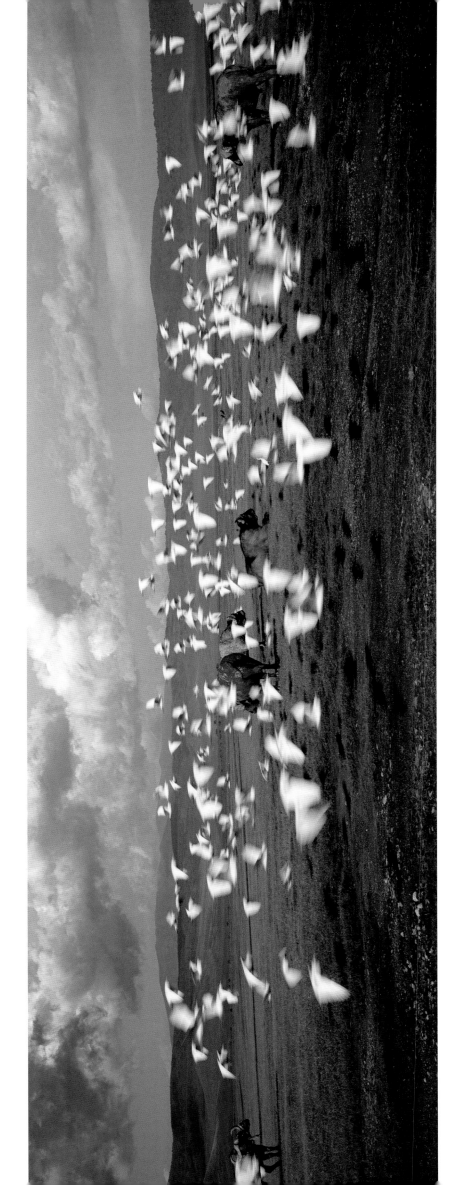

Ngorongoro Crater, Ngorongoro Conservation Area, Tanzania, February 2002

Cape buffaloes' expressions appear to claim, "We've seen it all," and judging by their relative longevity on the plains, this just may be true. These megafauna are challenging prey for lions not only because of their massive size and formidable cap of horns but also because the herds will form a circle to protect any vulnerable member.

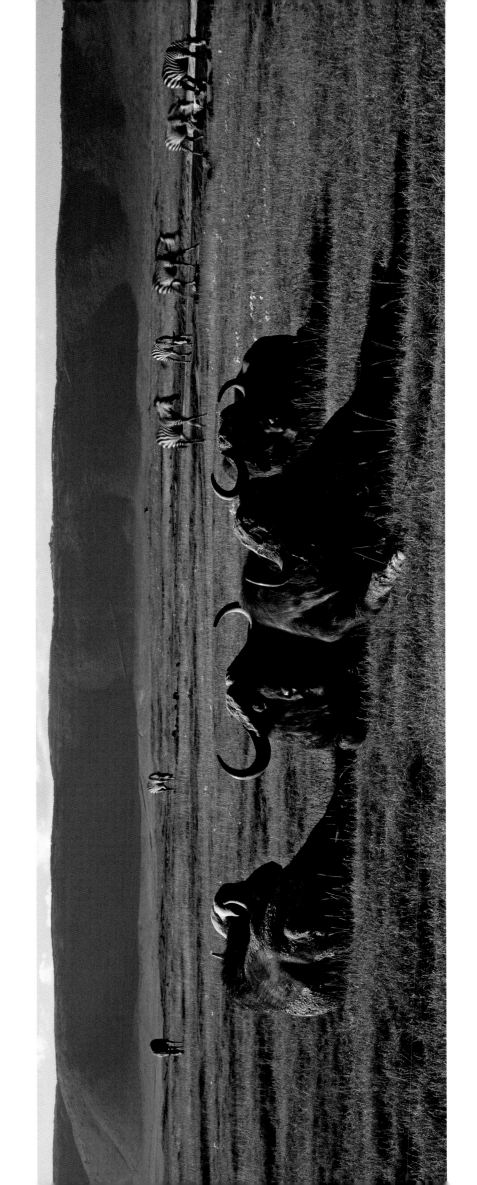

Ngorongoro Crater, Ngorongoro Conservation Area, Tanzania, February 2002

Lesser flamingos flock to Lake Makat as its waters grow and shift with the rains. Blooms of blue-green algae feed the birds, whose bills have evolved to function as filter pumps. Holding their heads upside down and skimming the surface of the alkaline lake, the flamingos make the most of this protein-rich food source.

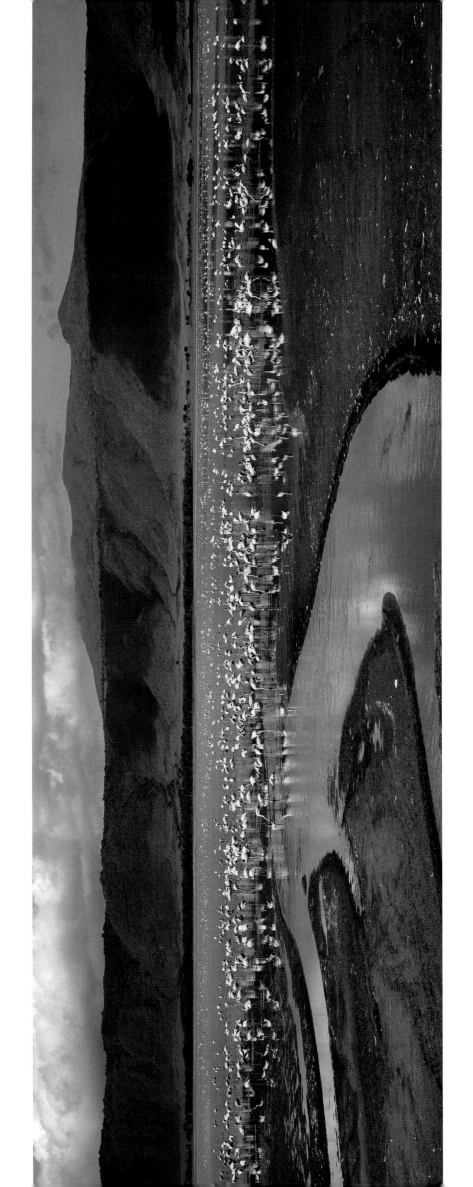

Lake Makat, Ngorongoro Conservation Area, Tanzania, February 2002

139

The rains of the Serengeti fall in shifts, drawing a wash of animals in their wake. Tonight, the showers relent; the sun fans out across the horizon.

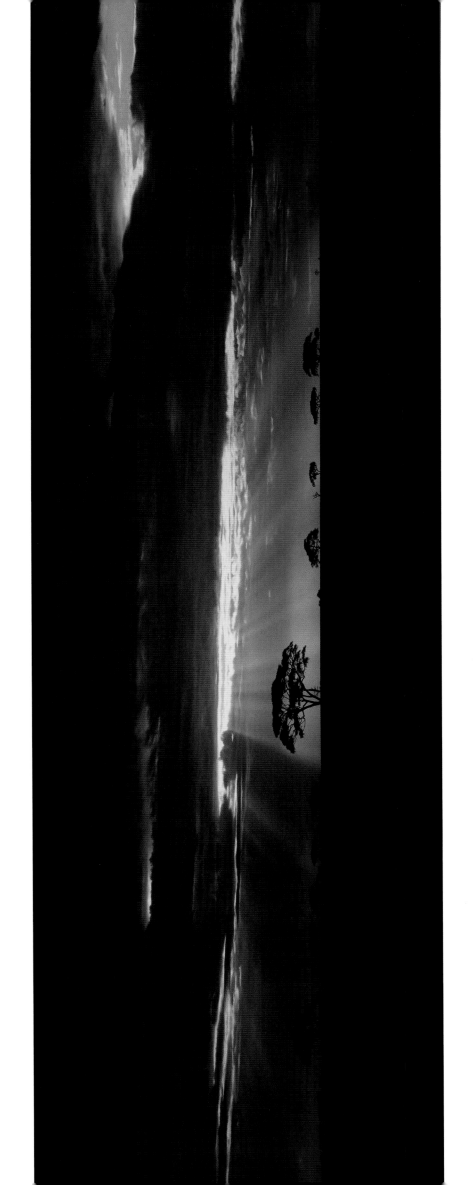

Cumulus clouds indicate a potential downpour, a sure sign that the rainy season has arrived. The showers attract ungulates numbering in the thousands, a welcome relief for lions who hold territories among the kopjes.

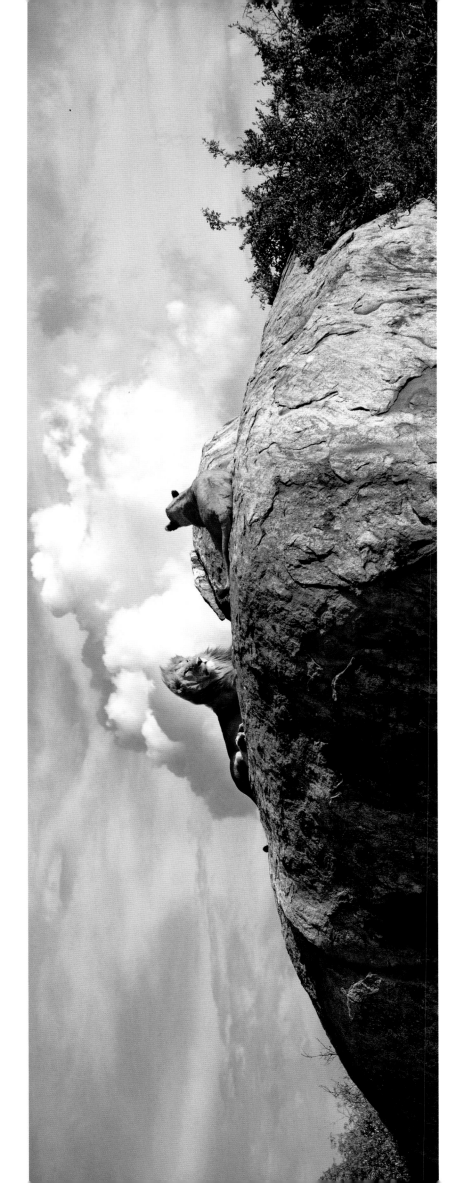

Serengeti National Park, Tanzania, March 2002

At sunrise, a herd of impalas pauses to feed on the gift of the rains. A single buck watches over his harem, snorting challenges to other males nearby. Tall grasses provide food but also leave the animals vulnerable. How much easier is it for a lion or cheetah to hunt from behind a screen of cover?

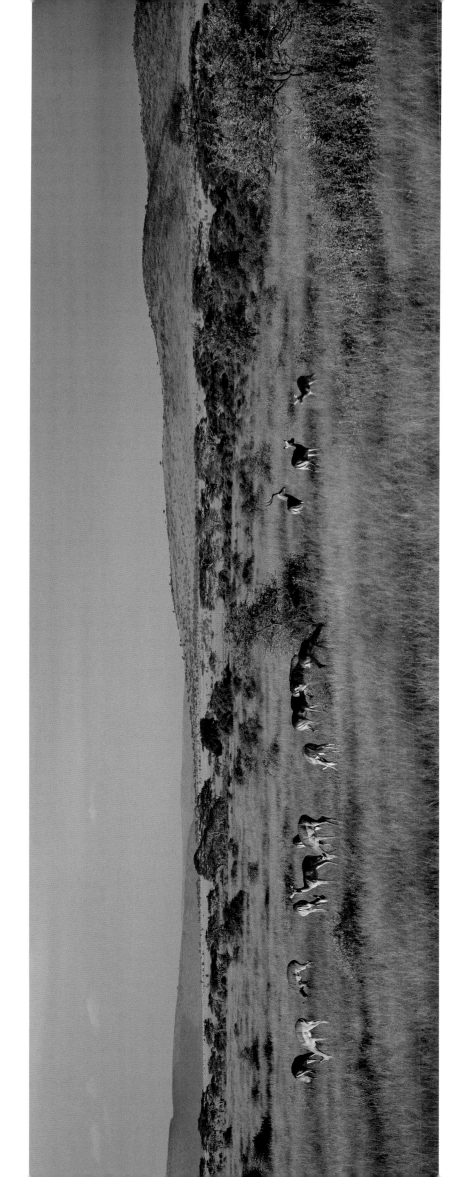

A cheetah gains a slight hunting advantage on the Serengeti plains from his vantage point atop a small hummock. While lions are also resident to specific territories, cheetahs are even more so, and truly depend on the passing of the migratory herds to survive. Grasses, which draw the herds, grow to maximum height and go to seed at different times and in different places throughout the Serengeti. For now, the cheetah will have to wait.

Serengeti National Park, Tanzania, February 2002

Hundreds of zebras flood the shallows of a swollen lake, a scene of fleeting tranquility. In less than fifteen minutes the zebras will have quenched their thirst, resuming their journey to graze on fresh grasses brought on by the rains.

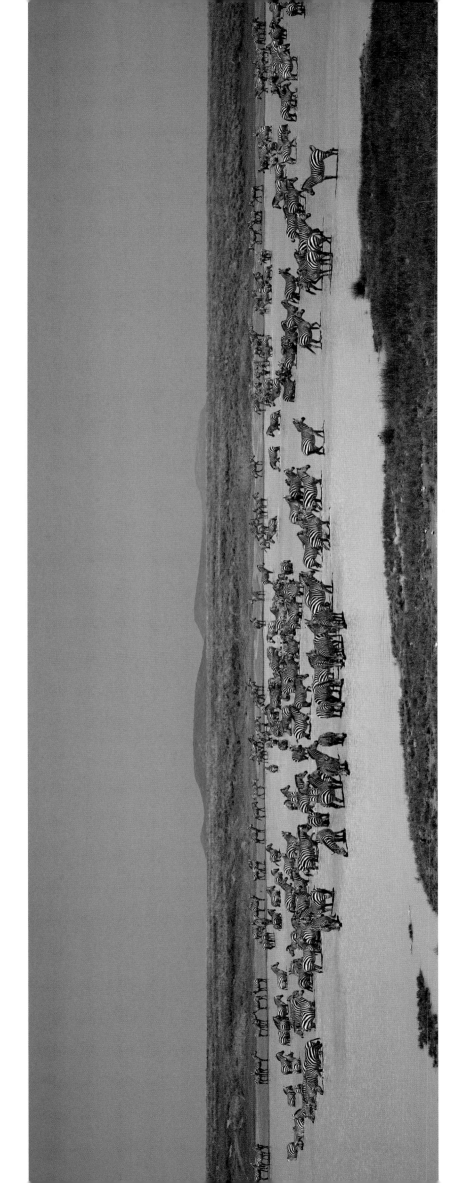

Along with lions, cheetahs are the other main predator who will lay claim to the granite outcroppings whose name in Dutch, kopje, means "little head." Representing a micro-ecosystem, these archipelagos of towering boulders support a unique diversity of life: from snakes and lizards who hunt between the rocks to the cat-sized hyrax, the quintessential kopje dweller.

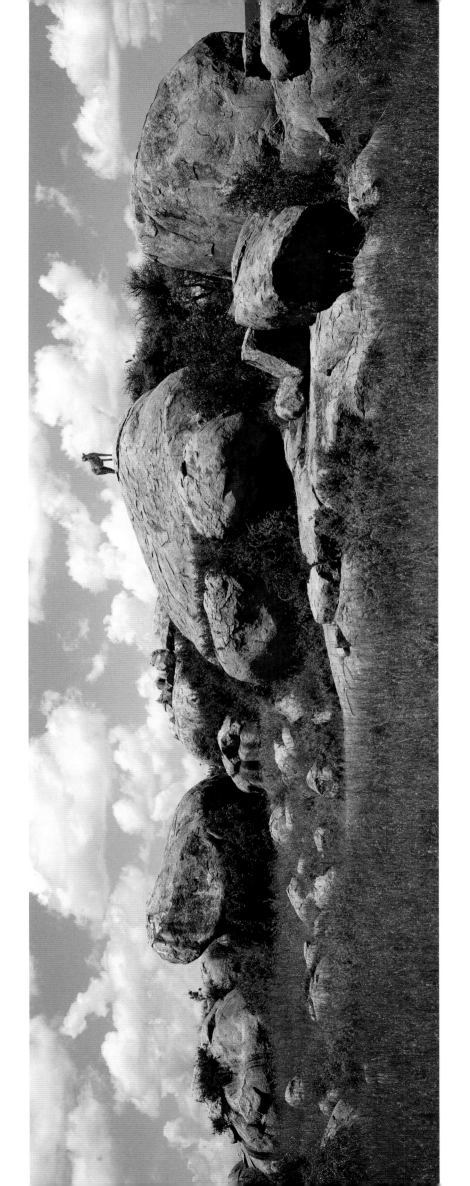

The land is alive: Migrating across the plains of the Serengeti, Burchell's zebras intermingle with the herds of constantly braying wildebeest. Seed-eating buffalo weavers often ride on the backs of the herds but now flutter in every direction, while cattle egrets and white storks catch insects stirred by the tides of the migration.

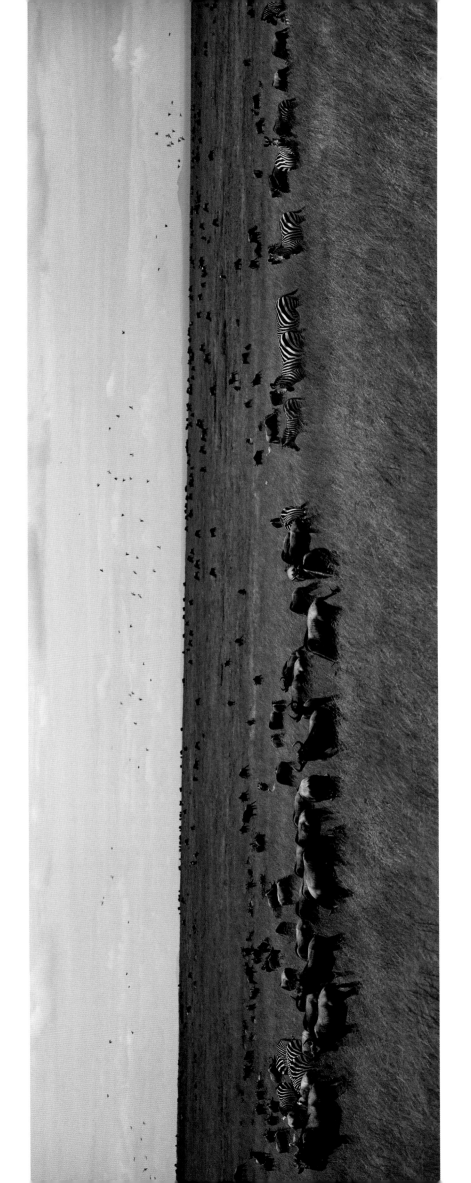

Spotted hyenas and vultures are two of the most unrelenting scavengers on the East African plains. It is likely that hyenas—adept, efficient predators known for their raucous, shrill cackle and ill-fitting mix of features (longer forelegs, stumped ears and inconsistently textured, spotted coat)—drove a lioness from her kill. The vulture hardly wins any beauty contest, either, but its hooked bill and naked-skinned head allow it to penetrate the body cavity of fallen prey to reach bits of meat the spotted hyena cannot.

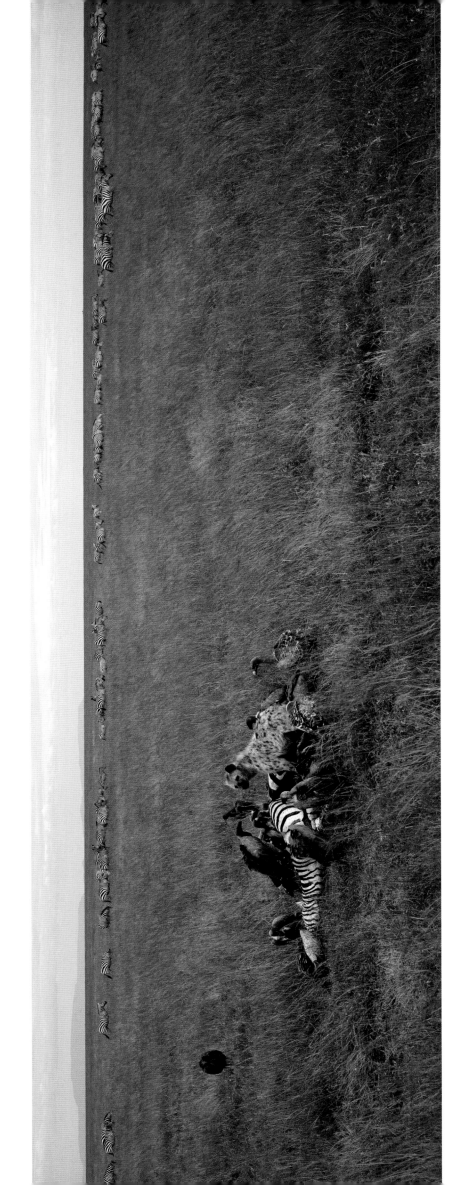

A lion in his prime—he bears a fully grown mane not yet worn short by a lifetime of battles with other males—peers from the heights of a kopje. Vultures are constant, hovering companions to the lions, who scan the horizon for arriving herds, eager for another opportunity to hunt.

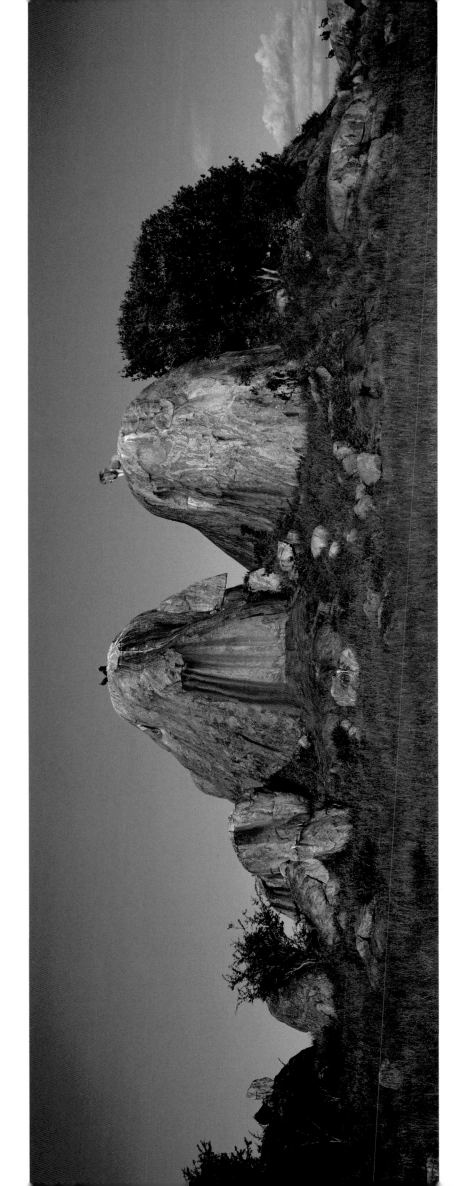

Today, the skies are wide and an endless supply of clouds skims the plains. The grasses come to life with the wind and perpetual movement of the herds traveling toward the gift of the rainy season. No sense is left untouched by the annual migration; it is on in full force.

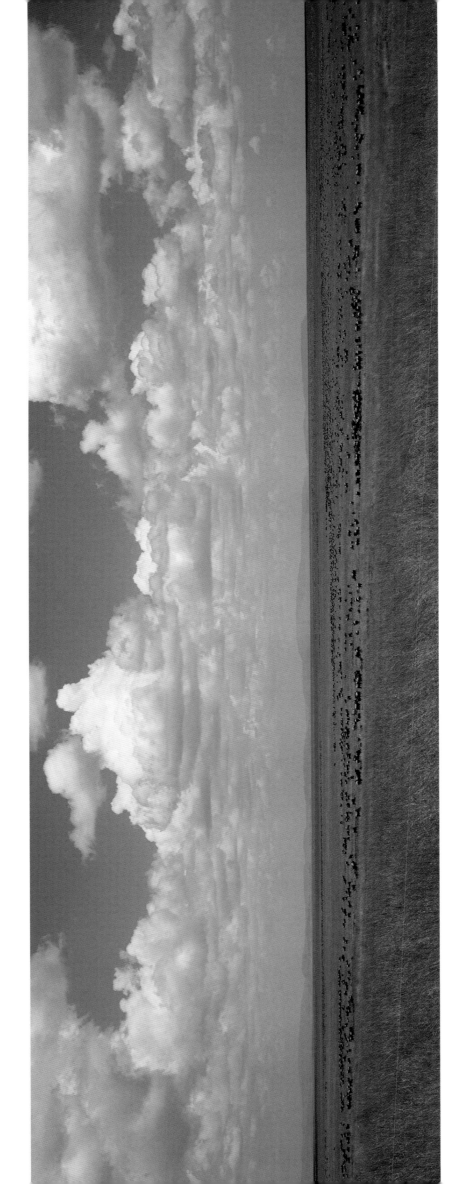

At first light, many nocturnal species of the Serengeti quiet their nightly ways: Leopards return to lofty treetops, the lucky ones full from a successful hunt; nightjars silence their whistling calls; and the rarely seen aardwolf slinks to a secret place, hidden on the land.

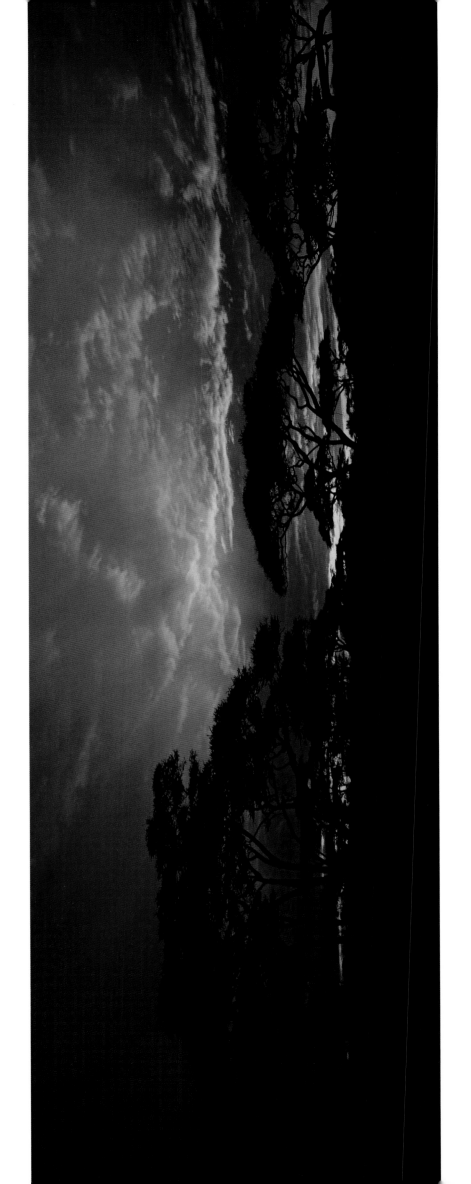

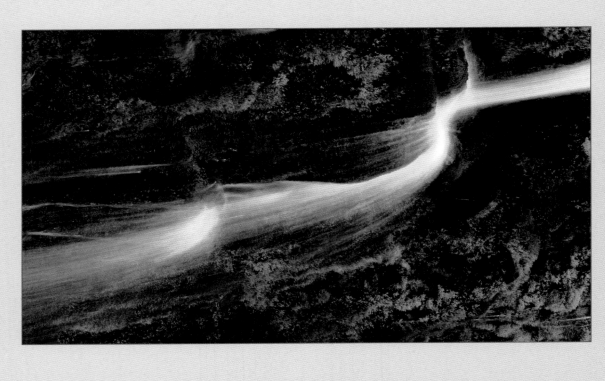

ICELAND

July 2005

After landing in Keflavik, Iceland, feeling jet-lagged but excited to explore a new country, I lug my tripod, duffel bags and three, seventy-five-pound Pelican cases filled with camera gear up the steps to the hotel. My back quickly reminds me just how much I miss Matt, my twenty-five-year-old nephew and camera assistant. He is a day behind due to a cancelled flight out of Omaha. Matt is not only young, strong and a good assistant and companion, but he also is interested in nature and wildlife and has become quite a skilled photographer. Each year one or more of my nephews joins me on a photography expedition. Matt has been to Hudson Bay for polar bears, coastal Alaska for brown bears and Rwanda for gorillas. Hopefully we will rendezvous tomorrow.

Iceland has intrigued me since my college days when I stopped here briefly en route to Europe during the spring of 1967. Iceland sits just below the Arctic Circle and is two-thirds of the way to London from New York. Relatively few people visited Iceland before Icelandic Air began offering cheap tickets to and from Europe in the 1960s, back when Yanks could spend the summer in the Old Country for five bucks a day.

This trip is a short, two-week near-circumnavigation of the island, starting in Reykjavik, Iceland's capital. The next morning, unshaven and a bit travel weary, Matt is delivered to the hotel. It is a relief to see him. He stuffs his pockets with the remains of the hotel's breakfast buffet, and we drive northeast along the coast toward Thingvellir National Park, home to stunning plate tectonic geology, lava formations and Iceland's largest and deepest freshwater lake, Lake Thingvellir. From there we head northwest, toward Borgarfjordur and the Snaefellsnes peninsula. It's a remarkable landscape, and looking around at the beauty of the place, I am reminded of what I said to myself in 1967, "I must come back here soon." I can't believe it has taken me nearly thirty years to return!

When my plane landed yesterday the weather was, according to several locals, better than usual. One thing Iceland is not known for is nice weather. The clear blue skies and gorgeous July conditions that greeted my arrival are deteriorating rapidly into low clouds and heavy drizzle. The windshield wipers barely keep up. Undaunted, we are anxious to make pictures and haul our tripods, cameras and umbrellas to two of Iceland's spectacular waterfalls, Barnafoss and Hraunfoss. Hraunfoss seemingly comes out of nowhere; springs a hundred yards long gush out of a low-lying hillside and flow into the Hvita River. Upstream, Barnafoss snakes its way sharply, twisting and turning and cascading through narrow chasms of igneous rock.

Between the rain and the waterfall spray we are soaked to the bone, and our equipment is, too. Much of Iceland's arctic-alpine environment is covered in glaciers, which produce thousands of falls in various sizes that flow into myriad rivers and lakes. Salmon and trout fishing are good. Matt and I naturally are attracted to the giant falls, those thundering hundreds of feet down a mountainside, but we are also drawn to those smaller, gentler ones whose waters heading to the sea fall quietly over brilliant green mosses. Barnafoss and Hraunfoss are the first of many of Iceland's spectacular waterfalls we will attempt to photograph. Hopefully our equipment will survive.

Over the years, I have photographed several of the Earth's great falls, including Iguazu, on Argentina's northern border with Brazil, and Victoria Falls in Zimbabwe. Although those are larger and more powerful than any in Iceland, the number and beauty of Iceland's falls are no less inspiring. Victoria Falls and Iguazu are products of big jungle rivers of the tropical rainforest. Iceland is a volcanic island where native forests were isolated and most of the trees were cut down centuries ago. Today in its reforestation efforts Iceland plants more trees per capita than any other nation in the world.

We arrive late in the evening at Hotel Budir on the Snaefellsnes peninsula. The three-story hotel sits on a hill overlooking the rain-speckled bay; there is no village, farm or other buildings nearby. Several dozen long-haired Icelandic sheep, considered one of the oldest breeds of sheep in the world, dating back eleven hundred years, graze among the wildflowers and long grasses of the jagged lava terrain. It is like a Hollywood set. In the bay common eiders and long-tailed ducks gather on the black sand beaches as the tide recedes. Arctic terns hover, dive and dip for small fish, capelin and sand lance. The fog lifts and the light changes. I want to spend the summer. Unfortunately, our schedule only allows three days on the peninsula, but they are days full of images of cliff-dwelling sea birds, stunning rock formations, including a sea-carved arch at Arnarstapi with gulls riding the wind, and a small, red-roofed farmhouse sitting on a bluff above the sea.

During the next few days we go to Stykkisholmur, where we take a boat to a small island and photograph a pair of nesting sea eagles. Later we catch a ferry north across the bay and drive west to Latrabjarg, the westernmost point of Iceland—and therefore Europe—and also home to Iceland's highest cliffs and most prodigious cliff-nesting bird colonies.

There Matt and I find ourselves perched on top of a fifteen-hundred-foot cliff, bracing against gale-force winds and horizontal rain, trying to find a photograph in all the mayhem. Below us there are millions of birds: Atlantic puffins, gannets, guillemots and razorbills coming and going from the sea. Just below us, several dozen puffins have dug nesting burrows into the side of the cliff. Some birds are standing at their burrow's entrance protecting a single egg; others are inside. Puffins are the size and shape of junior footballs, and going in and out of their burrows they remind me more of cottontail rabbits than birds. Matt holds onto my jacket to steady me, and I lean farther out over the edge to get a better picture. A small cat-sized arctic fox, Iceland's only native mammal, is running around the rocks at the bottom of the cliff. He's hunting for fledgling seabirds whose first flights didn't go so well. Having a bit of vertigo from looking through the camera, I realize that if I lean out too far my first flight won't be too impressive, either, and the fox will have an even bigger surprise than a flailing baby bird.

The circumstances are near impossible for photography, but the scene is breathtaking. Hundreds of seabirds hover below us, at eye level and at arm's length. After wasting a lot of film we settle on a pair of puffins hunkered down out of the wind in a bouquet of arctic daisies. Lovely little birds with striking facial patterns and multi-colored bills, they are totally unafraid. One is grey-blue-eyed and the other brown-eyed, and both have a remarkable patch of yellow at the edge of their cheeks that matches the yellow center of the daisies.

The cacophony of bird cries, the crashing of the surf and the smells of the sea are deep and exhilarating. This is quintessential Iceland, raw and wild, a place I won't wait another thirty years to return to again.

Inland glaciers feed the legions of waterfalls that cascade throughout the Icelandic countryside. Often visible only from the air, glaciers provide the land with a nearly continuous source of water, greening the place lush beyond imagination.

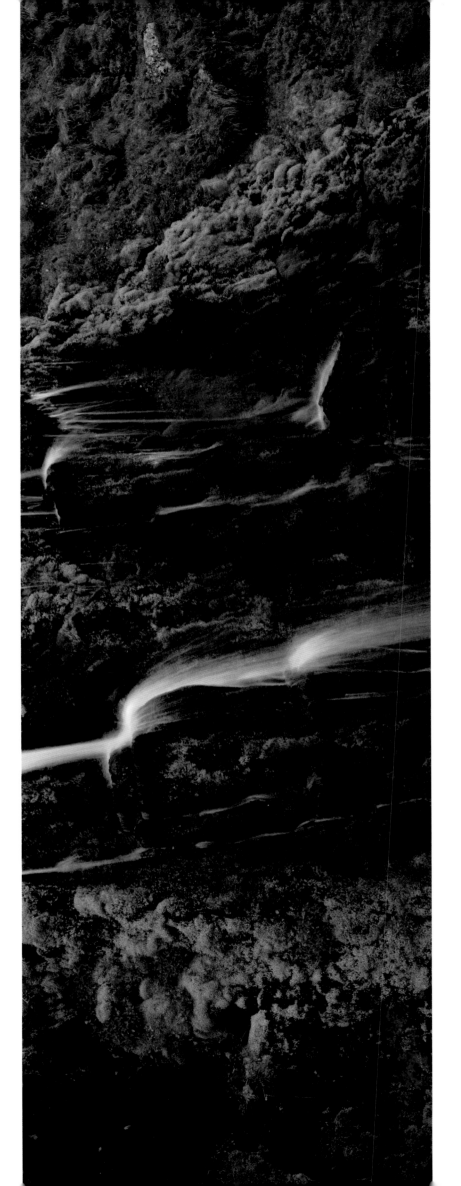

The one-and-a-half-mile-wide terminus, or foot, of the Skaftafellsjokull glacier is a recent outlet of the massive Vatnajokull ice sheet that covers about ten percent of Iceland. Estimated at around two hundred years old—considered young in terms of glacier years—Skaftafellsjokull releases sandy, silty debris as it drains.

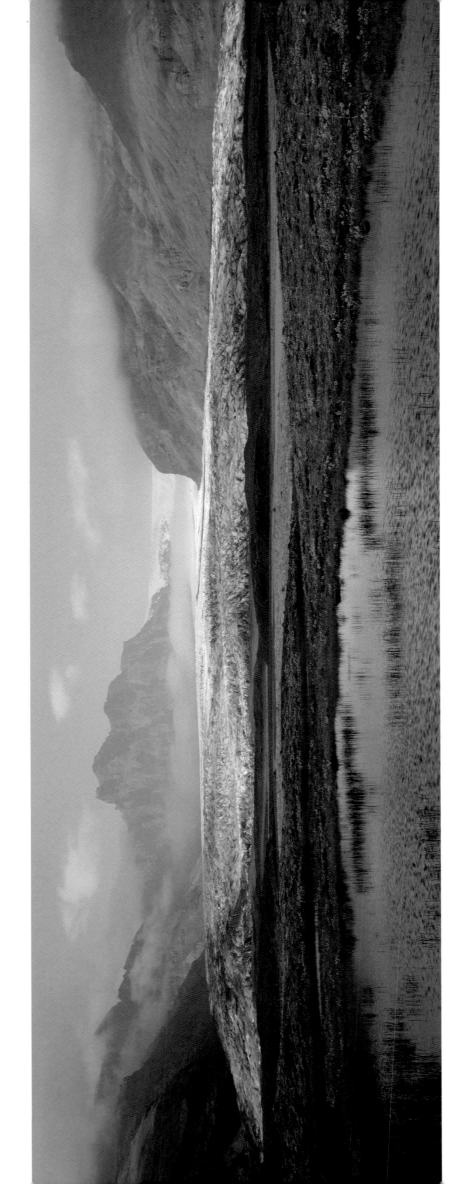

In the rich alpine habitat of Skaftafell National Park, wild thyme commingles with mosses and harebells, the flowers associated with sheltering fairies in folklore around the world. This southernmost area, though hardly settled by humans, is considered by many natives to be the most stunning of all of Iceland.

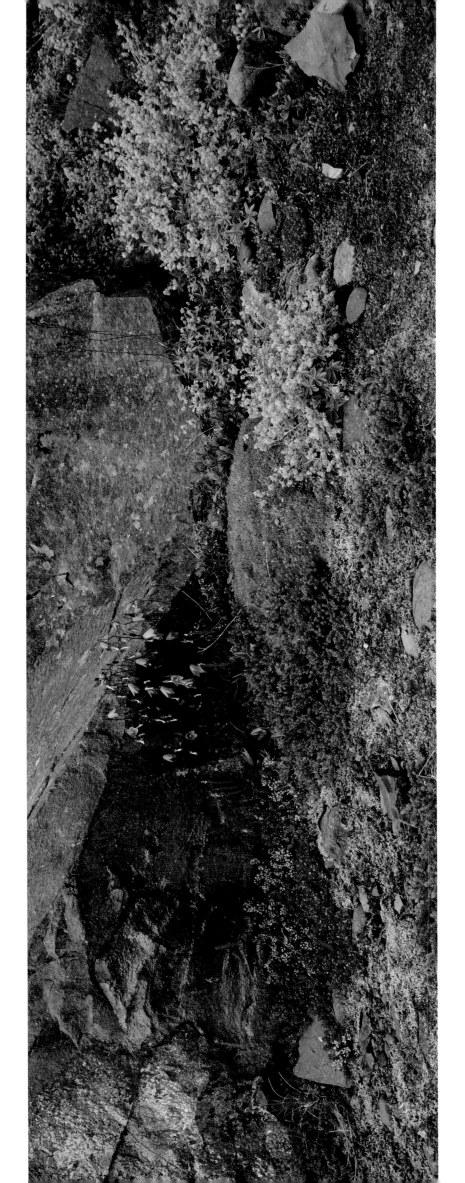

A coastal farm on the bluffs of West Iceland binds the history of this land with the Sagas, prose accounts that detail the country's discovery and settling in the tenth and eleventh centuries. This farm, near the village of Arnarstapi, presides over the many species of birds that nest on its cliffs. Herring gulls and kittiwakes are among the most common.

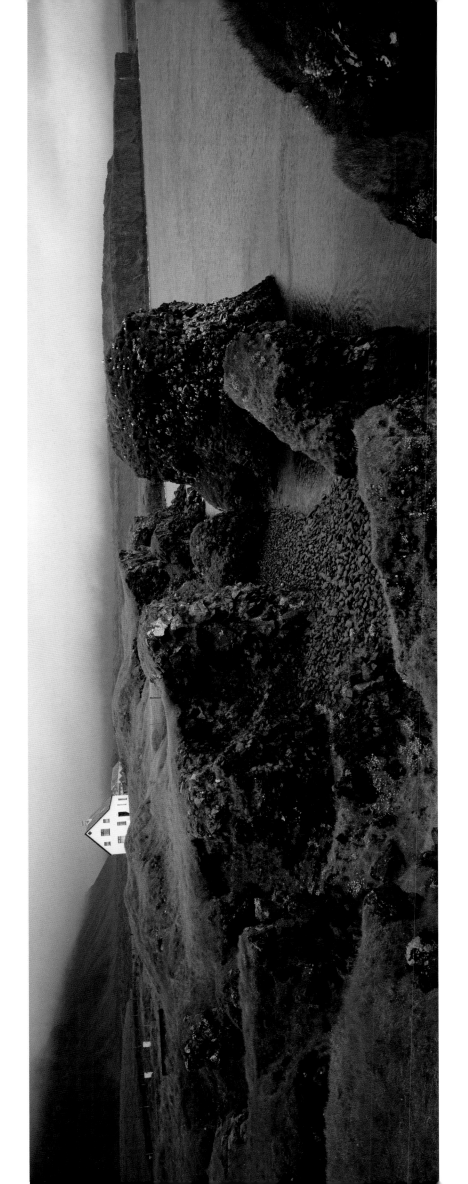

Midway through its evolution between a sea cave and sea stack, an arch carved by the repeated motion of waves defines one of the many coastal inlets of western Iceland.

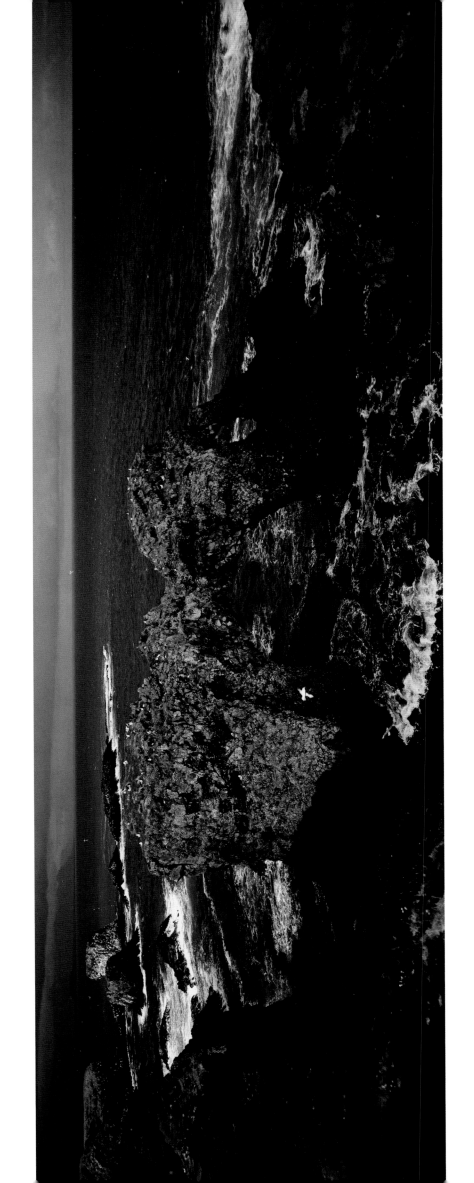

Gatklettur, Snæfellsnes Peninsula, Iceland, July 2005

Suspended columns of basalt frame Svartifoss, or Black Falls, in Skaftafell National Park. The pipe organ formation is testimony to Iceland's tumultuous volcanic history, as flowing lava, once cooled, created this place.

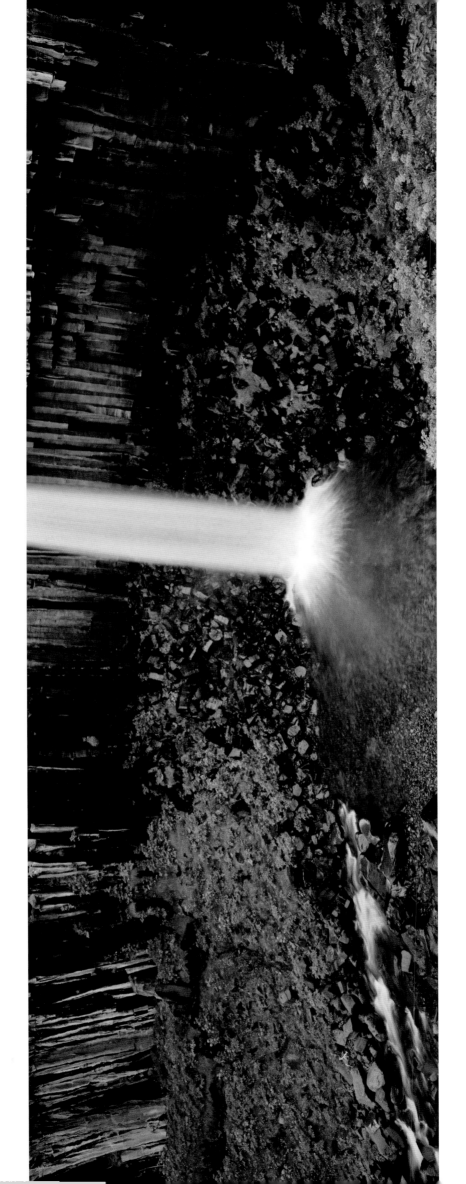

Svartifoss (Black Falls), Skaftafell National Park, Iceland, July 2005

The breaking up of the Breidamerkurjökull glacier happens in real time,

visible to the human eye as one sits in the lagoon where this finger of

Europe's largest ice sheet once rested, just yards from the Atlantic Ocean.

Most experts agree that this retreat is not correlated to global warming

but simply a correction,following the Little Ice Age, which consumed

farmlands in southern Iceland as recently as three hundred years ago.

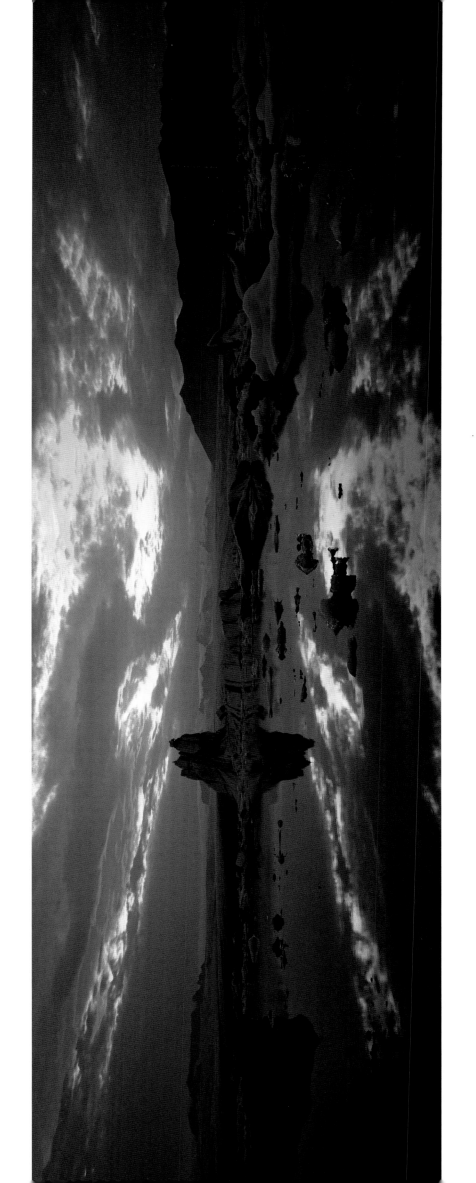

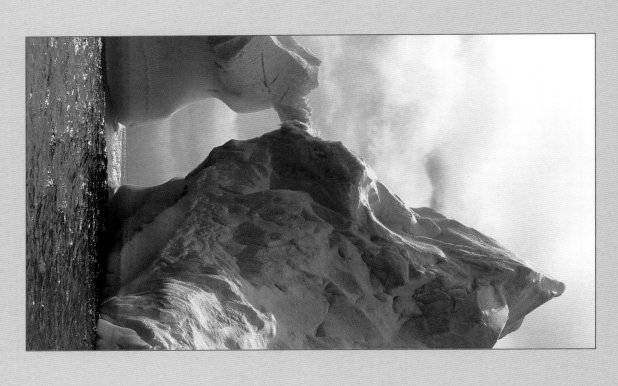

ANTARCTICA

December 2005

"Good morning everyone and welcome to Antarctica," comes the greeting delivered in the soft British accent of our expedition leader, who wakes us every morning on the PA system piped into our cabin. "Today we are in the 'true' Antarctic, the part of the Earth below sixty degrees south latitude." Throughout the night we had heard the crunching of pack ice against the hull of the ship, the *National Geographic Endeavour*, and I couldn't help but think of the *HMS Titanic*. The ship is now picking its way through the many icebergs, heading for Coronation Island, one of four islands that make up the South Orkneys. There we will see our first chinstrap penguins.

The scene out the porthole window is how one would expect Antarctica to look: blowing snow, giant icebergs and mountains with hanging glaciers rising from the sea, a southern giant petrel wheels in the wind. Once anchored, we load onto the Zodiac boats to go to the island. Stepping on shore, we make our way up a steep snowfield to the largest colony of chinstraps in the area, which boasts more than twenty thousand nesting pairs. Although the weather is very harsh today, it is not as bad as my previous visit here two years ago. On that trip, the weather was brutal, and the nesting penguins were plastered with snow and hunkered down protecting their eggs. Not so this time. It is two weeks later in the breeding season, some of the eggs have hatched, and the penguins are much busier, coming and going from the sea with bellies full of krill, some trekking up to the highest nests in the rocky cliffs above. The birds who have been tending their nests for many days are very dirty compared to those coming in fresh from the sea.

The red-colored guano, from the penguins' diet of krill, covers the landscape. A tiny, shrimp-like crustacean, krill is the primary food source for the birds and mammals of Antarctica. Freshwater melt from the icebergs and pack ice during the summer, along with near-constant daylight, encourages the growth of microscopic plant life that feeds the krill larvae. Since the early 1980s krill has seen a huge decline in population. This is most likely due to ozone holes, global warming and commercial fishing. Whales, now protected, were killed by the thousands during the whaling era of the early 1900s and have never recovered. Penguin numbers have also been affected. Many scientists believe that the decrease in krill is one of the principal factors negatively affecting the marine mammal and seabird populations.

Due to decreasing visibility and increasing winds, we are only onshore for a couple of hours. Leaving the South Orkney Islands, we sail along slowly making our way through the many icebergs along the coast. As we head south toward Elephant Island and out into the open ocean, the weather continues to deteriorate; the large swells make for a much smaller group at dinner. The metal covers on our porthole windows are clamped down tight, a likely sign of rougher seas ahead.

The following morning, as our Zodiacs crash through icy waves, we fancy ourselves pretty intrepid travelers; that is, until we close in on Point Wild, a tiny speck of land jutting out from Elephant Island, where Ernest Shackleton and his twenty-seven men landed their lifeboats in April 1916. They had spent the previous ten months drifting on an island of pack ice where their ship, the *HMS Endurance*, was trapped and eventually crushed. The incredible voyage of Shackleton and his men became even more astonishing once we saw the rocky, barren spot where the crew of twenty-two spent one hundred and thirty-seven days, with overturned lifeboats as their only shelter, as Sir Ernest and five others headed to South Georgia Island, eight hundred miles away, to find help. Amazingly, Shackleton and his twenty-seven men all survived.

Sailing south, there is ice everywhere: icebergs of all shapes and sizes, tabular bergs the size of a city block, and icebergs that tower a hundred feet above us. Out on deck, we find ourselves constantly watching for the next "most amazing" shape or color.

The following day we land on the Antarctic Peninsula at Brown Bluff, where thousands of gentoos are feeding their week-old chicks. Long lines of Adélies march along the rocky shoreline, some detouring and clambering up a small beached iceberg and nibbling its freshwater ice, as pintado petrels dip and plunge after its zooplankton. A rare sighting of a snow petrel on its nest, well hidden under a boulder high on the bluff, rounds out our morning.

Next is Whalers Bay and Deception Island, site of an old whaling station and a British Antarctic Survey base, deserted after a volcanic eruption in 1970. Old rusty tanks, decaying buildings and graves marked with two white crosses are all that remain. Early the next morning the captain carefully navigates through the narrow Lemaire Channel with its 3,000-foot peaks and some of Antarctica's most spectacular scenery. Once through the channel, we come to Petermann Island, whose rounded granite rocks are covered with gentoo penguins. A lone Adélie decorates a small blue iceberg floating in the bay.

Pack ice is everywhere now and it splinters ahead of the ship in long cracks; we hear the slushy sound of the ice sliding along the hull. The sea is calm, steel grey in color, with towering peaks in the distance shrouded in clouds. There are numerous crabeater seals and the occasional Weddell seal sprawled out on the ice. It is this scene that greets us on Christmas morning. The captain wedges the ship into an expansive ice floe and turns off the engines. The silence is welcome. The gangway is lowered, and all the passengers and crew scramble out onto the pan of ice to make snowmen and take pictures of each other as a crabeater seal observes the festivities. It is a Christmas day to remember in one of the wildest and most pristine places on Earth.

Awe-inspiring, Antarctica's icebergs shift and collide, creating thousands of smaller satellites of ice adrift in the southern seas. Calved from colossal ice shelves thousands of years old, these transitional islands are used by pelagic—open ocean—birds as resting places during their time at sea.

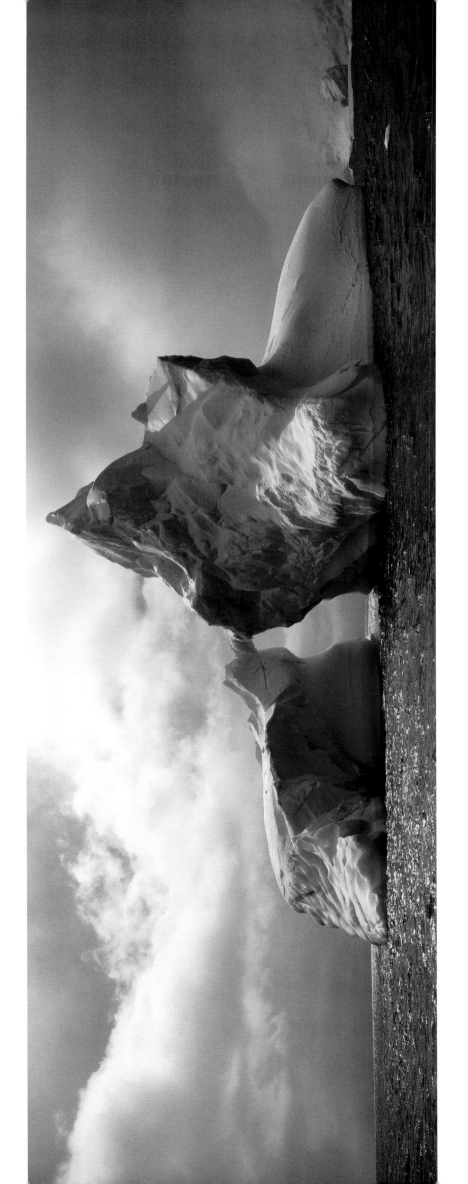

Wicked springtime weather plagues a ridgetop colony of chinstrap penguins who respond by hunkering down to protect their eggs. True mountaineers among penguin species, chinstraps sometimes hike two to three miles uphill to their windswept and snow-free nests.

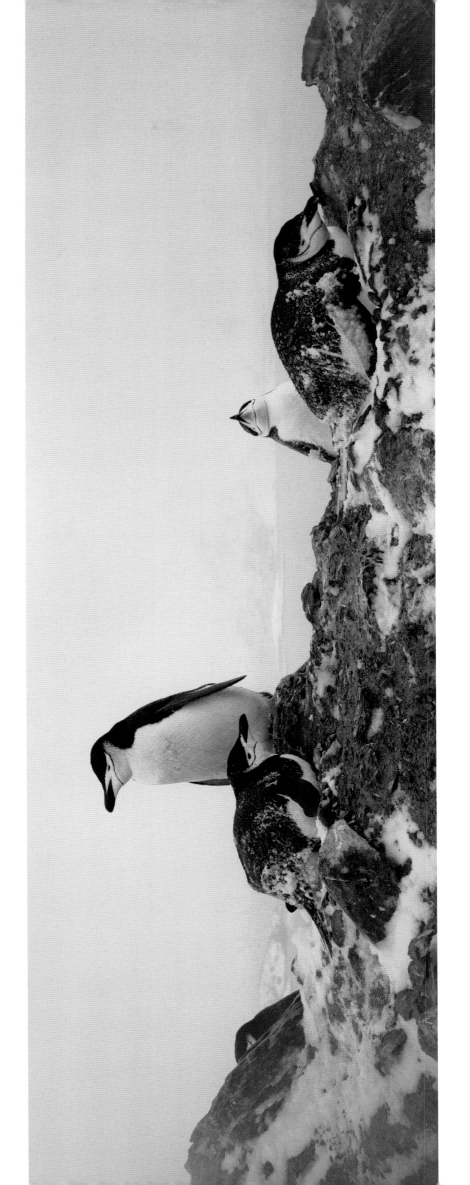

Shallow bays ground transient icebergs around Cuverville Island, home to Antarctica's largest breeding colony of gentoo penguins. The red-tinted snow of the colony results from minerals found in penguin guano and a diet rich in krill. A shrimp-like crustacean, krill is the primary food source for many species of birds and mammals throughout this extreme southern region.

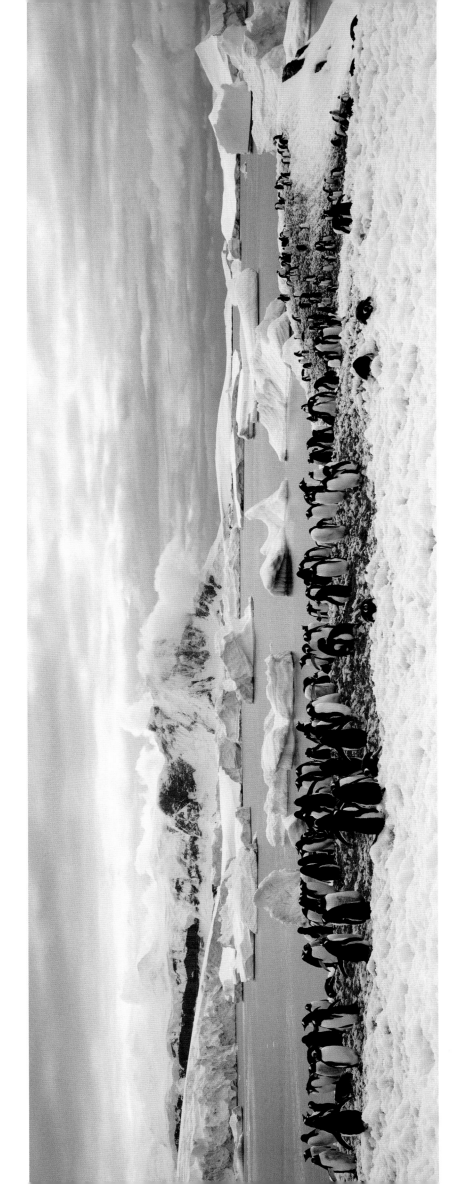

Cuverville Island, Antarctica, November 2003

As the evening sun breaks through springtime clouds, a tabular iceberg's stature challenges the proportions of terra firma. In March 2002, an unprecedented section of the 720-foot-thick Larsen B ice shelf collapsed. The recent rapid decay of Antarctica's ice sheets is changing the shape of the continent; bergs such as this one have become a much more common sight along the Antarctic Peninsula.

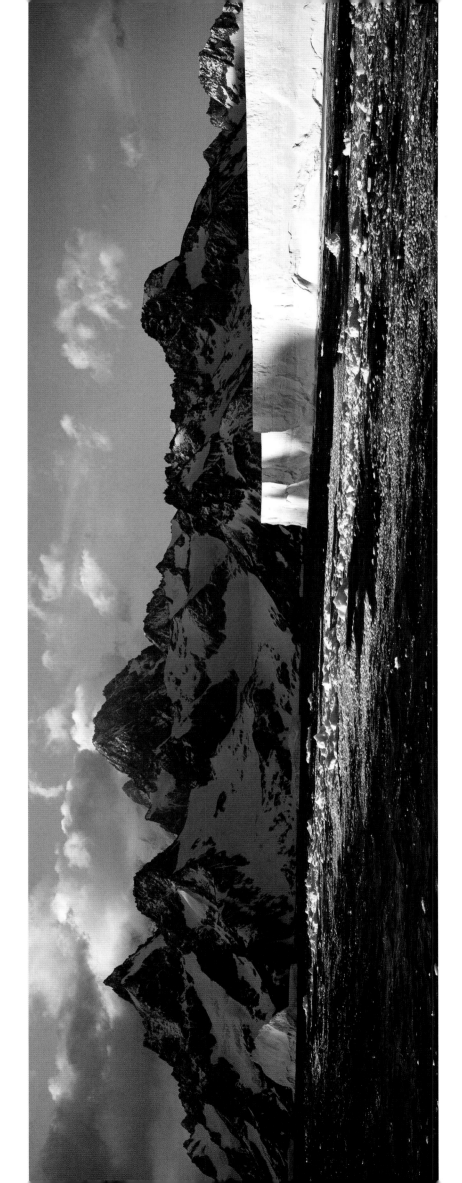

With swimming speeds clocked at twenty-two miles per hour, gentoos hold the record as the fastest swimmers of all penguin species. Their eyes have flat lenses to optimize underwater sight. But on land, this adaptation makes life more difficult—it is harder for the birds to see obstacles in their path.

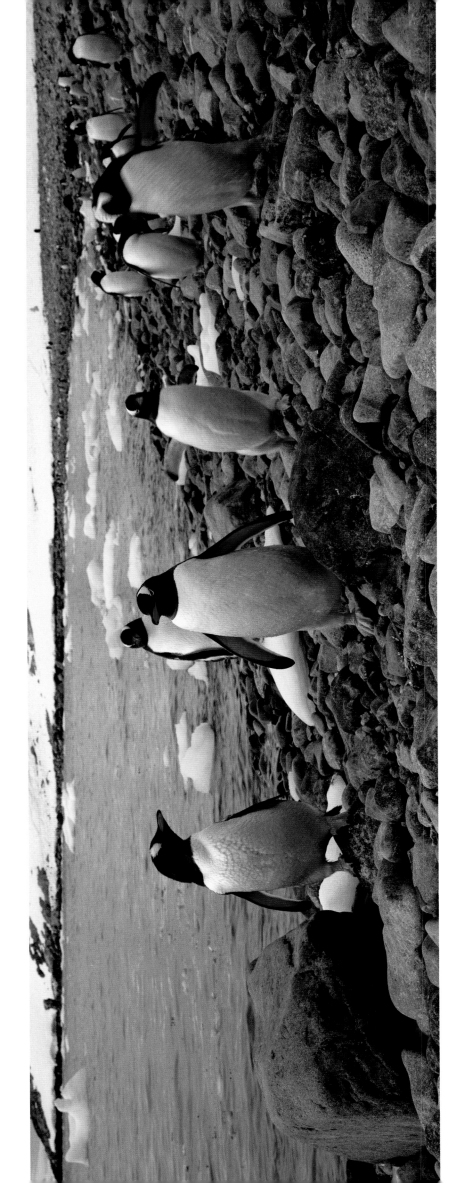

Rock and ice dominate the landscape of Antarctica. With only two percent of the continent exposed, lichens and mosses are the first, and often only, plants to colonize bare rock. An extension of South America's Andes, the Antarctic Peninsula is connected by a sweeping underwater mountain chain known as the Scotia Arc.

The bleached bones of a large baleen whale are grim remnants of a booming industry that took the lives of as many as 1.25 million cetaceans in the last century. The calm waters at Port Lockroy sheltered one of Antarctica's six shore-based whaling stations. These land operations supplemented the forty-one floating factories in operation preceding World War II.

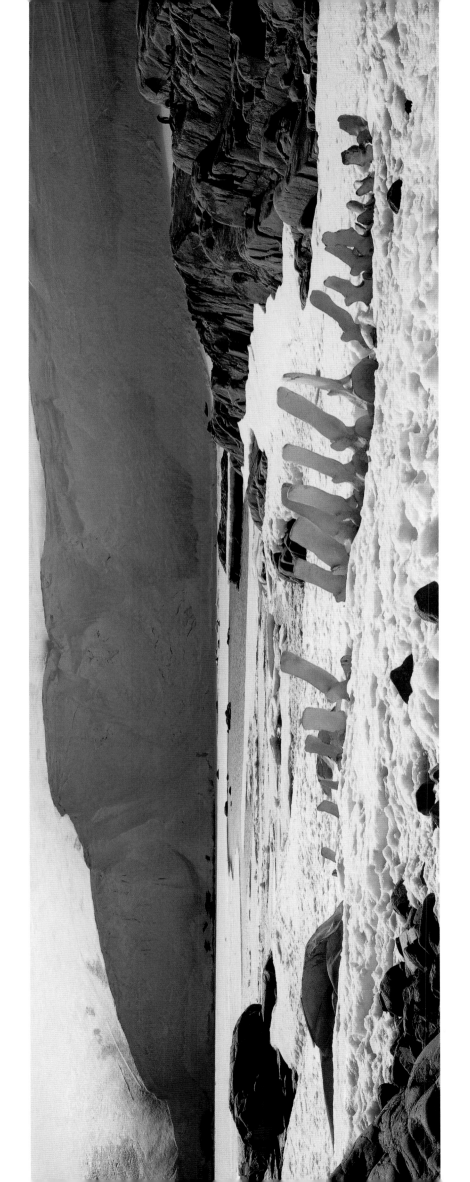

Port Lockroy, Wiencke Island, Antarctica, December 2005

Scattered gravesites, some of them marked with simple wooden crosses, are all that remain after decades of whaling activity on Deception Island. The island's ash-covered slopes indicate the volcanic nature of this place, with latent geothermal activity that echoes its distant-relative caldera in the Northern Hemisphere, Yellowstone.

Whaler's Bay, Deception Island, Antarctica, December 2005

195

Adélie penguins scale icebergs to nibble away at freshwater snow, but whether or not they play is strictly a matter of opinion! The beach at Brown Bluff is covered with silver-gray stones worn smooth by the tides of the Southern Ocean, recognized as one of the most violent of seas.

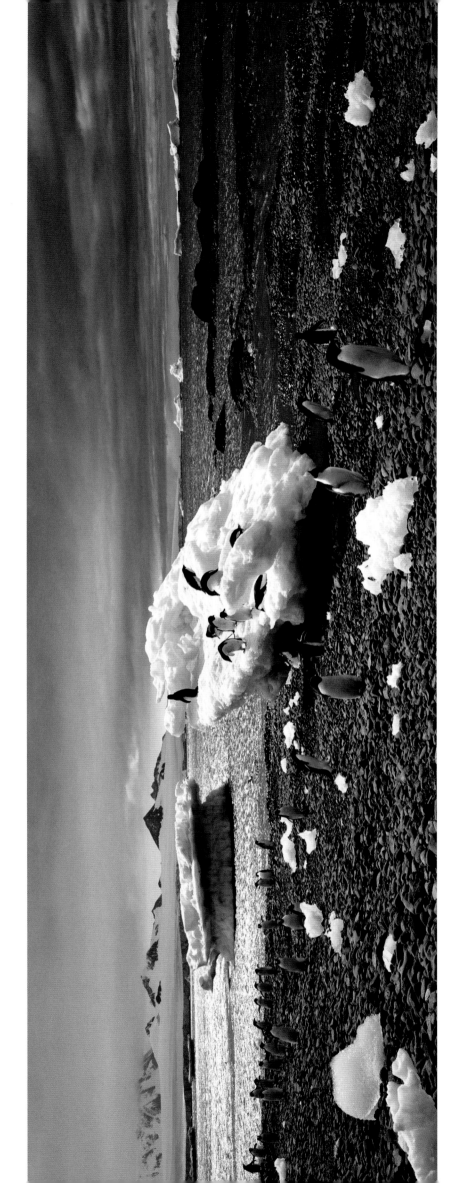

Brown Bluff, Antarctic Peninsula, December 2005

Dry dock erosion forms the deep, U-shaped crevasses on this glacier-turned-iceberg calved from the Antarctic mainland. The myriad ice floes, bergs and shelves of the Antarctic seas dazzle the imagination with their colors, shapes and sizes. This topaz-blue shade indicates that the ice is free of air bubbles and gases, its frozen substance compressed by thousands of years of pressure.

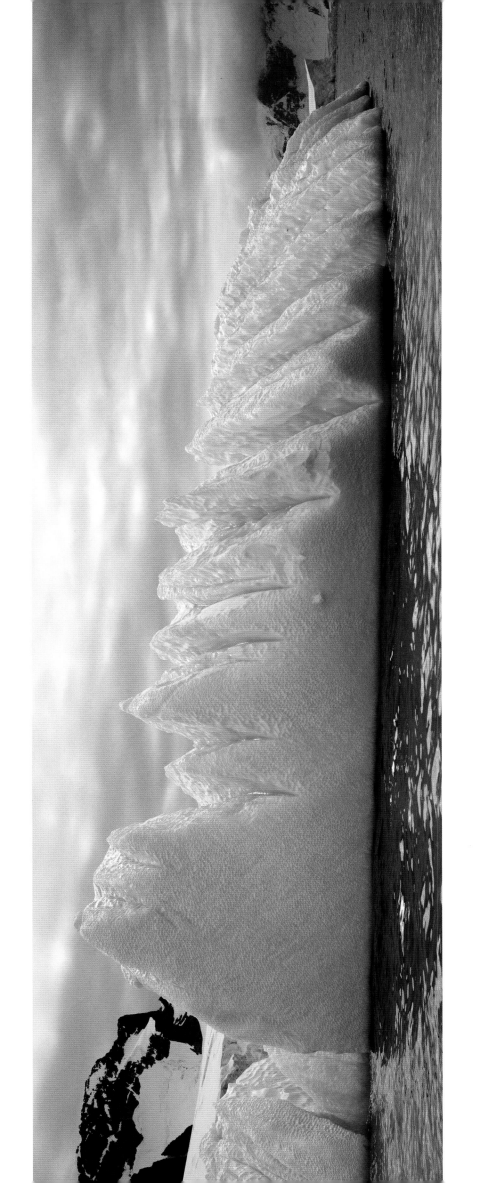

Cuverville Island, Antarctica, December 2005

The size of a city block, a wedge-shaped iceberg twenty stories high floats south of the Antarctic Convergence. This zone is roughly thirty miles wide and acts as a biological barrier separating two distinct climates and marine environments. Heading south across the Antarctic Convergence the temperature drops; when the first icebergs appear, you know you have arrived in Antarctica.

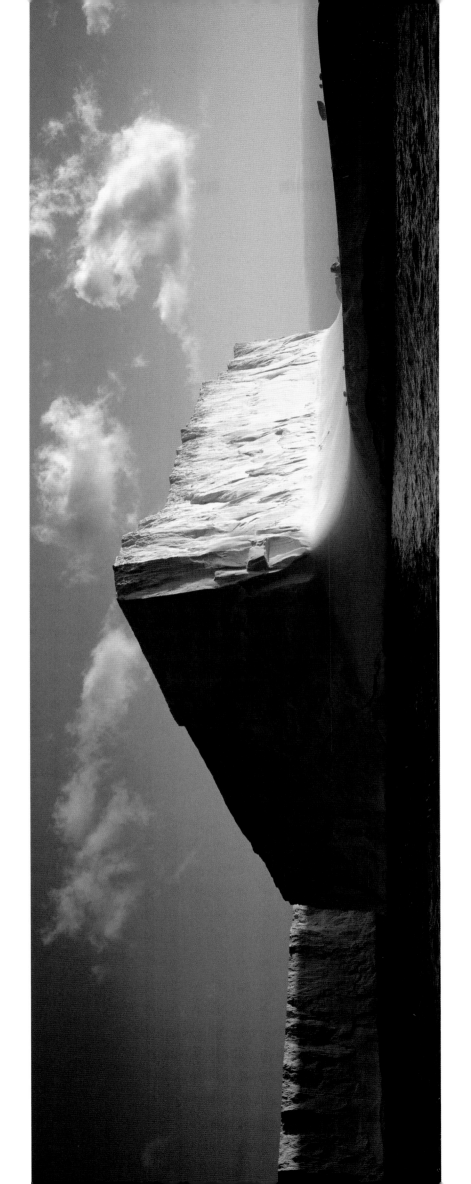

GREATER YELLOWSTONE

September 2003

This morning is the last day of the photo workshop. I have met up with a dozen intrepid students, those who haven't succumbed to the too-many short nights and long days of the past week. They stand in the frosty darkness at 5:30 a.m., clutching their Thermos bottles and cups of strong coffee, bleary-eyed and as excited as one can be, considering the time of day.

We drive north past Timbered Island and Jenny Lake, heading to the Oxbow Bend. The silver-blue eyes of a herd of elk dance in the headlights. As the eastern sky begins to lighten, the silhouettes of two dozen cows and a six-point bull etch the horizon. We stop, get out of our vehicles, and listen. A chorus of bull elk bugling and whistling pierces the morning stillness. From every direction, bulls challenge each other. Several are within a hundred yards or so, others a mile or more away. We cup our hands, like mini-parabolas, behind our ears to tune in the distant ones. Now wide-eyed and with wide smiles, the students scramble for their binoculars, tripods and spotting scopes. A few overly optimistic ones wrestle with their biggest and longest lenses. I gently chide them, "I don't care if you are shooting digital, it's still dark."

I am reminded of why I help teach a couple of workshops every year: not really to teach, but to experience the excitement and joy of those discovering something new. For the students in the group who have never heard an elk bugle before, it is pure magic; for those, like myself, who have experienced bugling many times, it is still a wonder. There are only a handful of sounds in the natural world that give me the same sensation.

Several are universal, I suppose, like the call of a loon on a northern lake, the roar of lions in the African night or the howling of a pack of wolves on a cold winter morning. Personally, I would include two more: the loud trumpet calls of migrating whooping cranes over the Canadian prairies in the fall, and the ancient cries of sandhill cranes during spring on the Platte River in Nebraska.

We need to move on if we are to catch the first rays of light on Mount Moran at the Oxbow. Most of the students are reluctant to leave, and I don't blame them. It's always tempting to stay and wait for the light to hit the elk, but I have learned from experience that before the sun comes to these meadows, the herd will disappear into the dark timber. Unlike the elk in Yellowstone that remain visible all day, the elk in Teton Park, who are hunted within the park boundaries, have adopted a more protective nighttime schedule. It is only now, during the height of the rut and the rush of hormones, that these elk let down their guard at dawn and dusk; when late October comes they will be fair game.

For numbers of animals, variety of species and sheer beauty, the Oxbow Bend of the Snake River is hard to beat. Everyone spreads out along the shore, sets up their tripods and composes the scene. At 6:45 a.m., the first rays of sunlight strike the top of Mount Moran. A half-dozen white pelicans swim in the nearest bay, while several dozen Canada geese, mallards and widgeon loaf, preen and feed on the middle mud bar. There is not a breath of air; stillness reigns.

Along the far shore a pair of beaver cut a "V" in the glassy, calm water as they drag freshly cut willows to their lodge around the bend.

Every imaginable lens, angle and composition is experimented with to best capture Mount Moran, the fall colors and the wildlife. We mostly work on reflections: reflections of the Tetons and reflections of the aspens. By 8:30 a.m. a slight breeze comes up and the reflections disappear, and it seems we have exhausted all the potential Monets, Adams and Porters. The group is thinking food, lots of food: pancakes, eggs Benedict, bacon and lattes. We begin packing up, but now I am the one reluctant to leave. As I open the end-gate and lift my tripod into the car, I look back at the scene. The breeze has quieted and the water is again calm. In twenty-five years I have never seen the aspens so glorious here. Though it is late, photographically—the "magic hour," the hour on either side of sunrise and sunset, has passed—the scene still looks beautiful. Thinking to myself it may never be like this again, I decide to stay, as the rest of the group hurries off to breakfast.

I grab my tripod and backpack and head down to the shoreline where I was set up earlier. After eating a granola bar and finishing the last of the coffee, I doze off for a nap. At high noon, I wake to the rushing sound of big wings at high speed over my head, and look up to discover a bald eagle in hot pursuit of an osprey clutching a cutthroat trout, not more than ten yards above me. I instinctively reach for my Nikon with the 80-200mm lens and in a major panic realize I have left them in the car. Unbelievable! The osprey and eagle

swoop, circle and dive. Perfect for the 80-200mm! In desperation, I grab the panoramic camera, which is still mounted on the tripod, spin around on my knees and looking through the viewfinder try and catch up with the eagle and osprey doing battle behind me. It is impossible! I shoot and waste one frame and realize I have only two frames left and tell myself, *Don't blow it. Just maybe they will go back west in front of Moran.* I reframe the original scene, change the shutter speed from 1/8 of a second to 1/500 to stop the birds' motion and change the aperture from f/45 to f/8 to compensate for the loss in light. At that very second, the birds turn toward the mountains and enter the scene. The osprey is forced to drop his catch, the eagle swoops upward against the blue sky and momentarily stalls, looking back over his shoulder as the trout hits the water. The eagle and osprey circle, the eagle dives toward the splash hoping to claim his pirated prize, but the fish sinks out of sight, its air bladder likely punctured by the osprey's talons.

It takes me awhile to collect my thoughts and replay in my mind what I have witnessed and possibly, but not likely, captured on film.

Over the years I have seen several eagles chasing osprey with fish, but had never watched such incredible behavior so close, and although I have seen eagles from time to time on the Oxbow, I had never seen one in front of Mount Moran!

There comes a time when, as a photographer, you realize, *This is as good as it gets.* So no, I don't spend the rest of the day on the Oxbow just to see what may happen; I run into town to get my film developed.

A vanishing ripple on the water's surface is all that remains of an aerial battle between a bald eagle and an osprey over a cutthroat trout. Known competitors, the two birds take turns displaying dominance, with the bald eagle using its size to intimidate the aerodynamic osprey. This time both lose, and circle the Oxbow Bend of the Snake River to make another try.

There is no trail in this forest of aspens, only a thick undergrowth of willows to camouflage the paths of animals who relish the protection of this place: elk cows with their calves, yearling moose, coyote pairs and the occasional cougar with her cubs, searching for a site to keep her young out of harm's way.

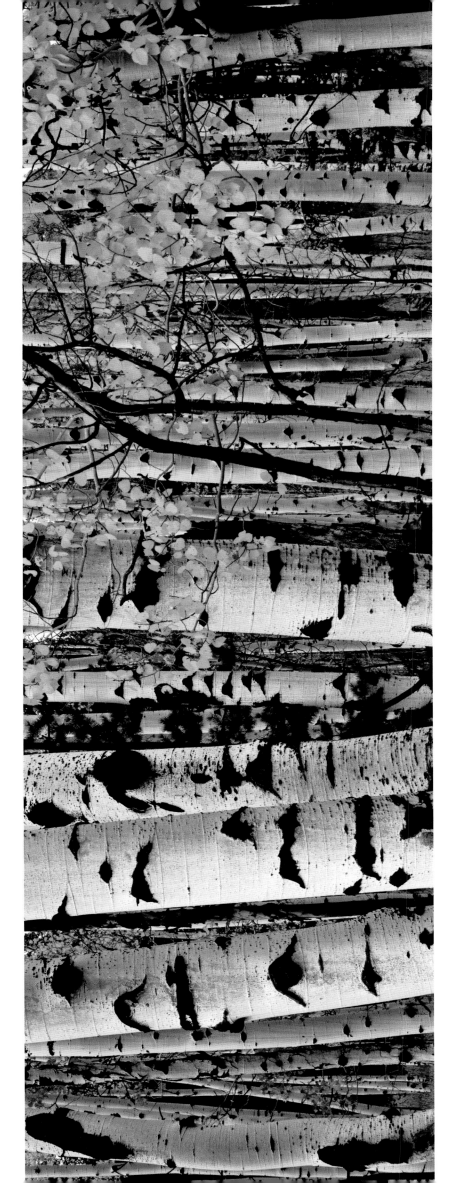

Thunderstorms and constantly changing skies over Lake Yellowstone echo the equally turbulent subterranean dynamics at work in America's first national park. A complex geological wonder is at play here, making the Yellowstone Caldera one of the known supervolcanoes of the world.

Yellowstone Lake, Yellowstone National Park, Wyoming, USA, August 2004

The Lamar Valley in northern Yellowstone provides a herd of bison solace and the chance to graze in peace. An estimated sixty million to seventy million bison roamed North America in the late 1700s. But by 1890, fewer than eight hundred bison remained. By the winter of 1901-02, only twenty-three bison were counted in Yellowstone, believed to be the last wild herd in North America. In 2005 park bison deaths reached a nine-year high: Nearly 900 wild bison were killed by state and federal authorities who fear the spread of the disease brucellosis to domestic cattle.

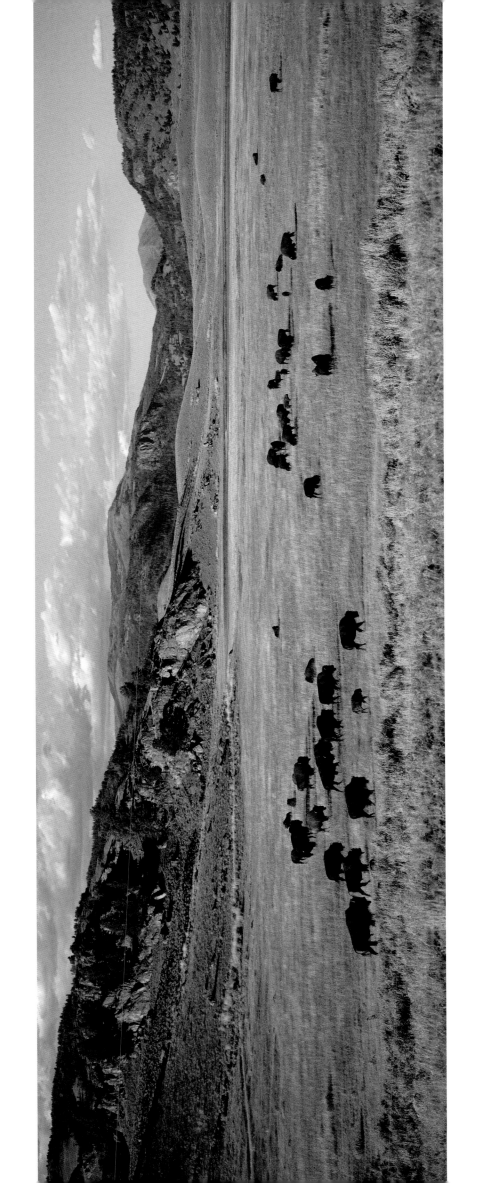

Lamar Valley, Yellowstone National Park, Wyoming, USA, October 1995

Carved by repeated glaciations and seismic activity, the cliffs of the Grand Canyon of the Yellowstone serve as favorite nesting places for osprey. The color of the canyon—a result of thick layers of accumulated volcanic ash and layers of oxidizing rocks—is the root of the park's name, Yellowstone.

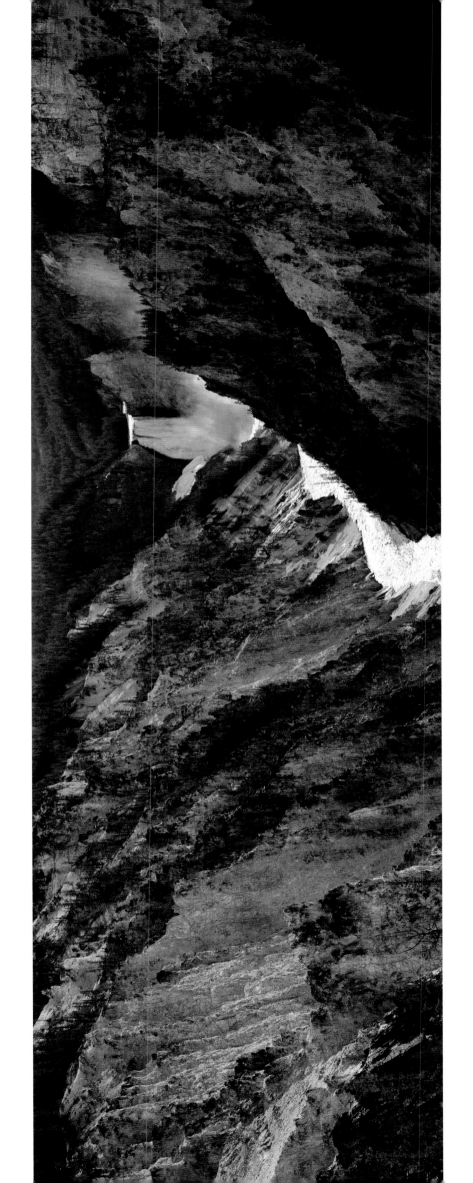

An elixir of hot water, calcium carbonate and volcanic activity forms the many travertine terraces and cone caps of Mammoth Hot Springs. The oranges, pinks, greens, blues and browns are an aesthetically pleasing product of micro-organisms and living bacteria that, combined, create another species of rainbow.

Rising fog from hot springs creates a magical setting north of the Old Faithful Geyser. This tranquil scene underscores the lethal repercussions of living so near Yellowstone's famed thermal features. The overflow of geyser water, rich in minerals but deadly for trees, will petrify a block of wood in only a year.

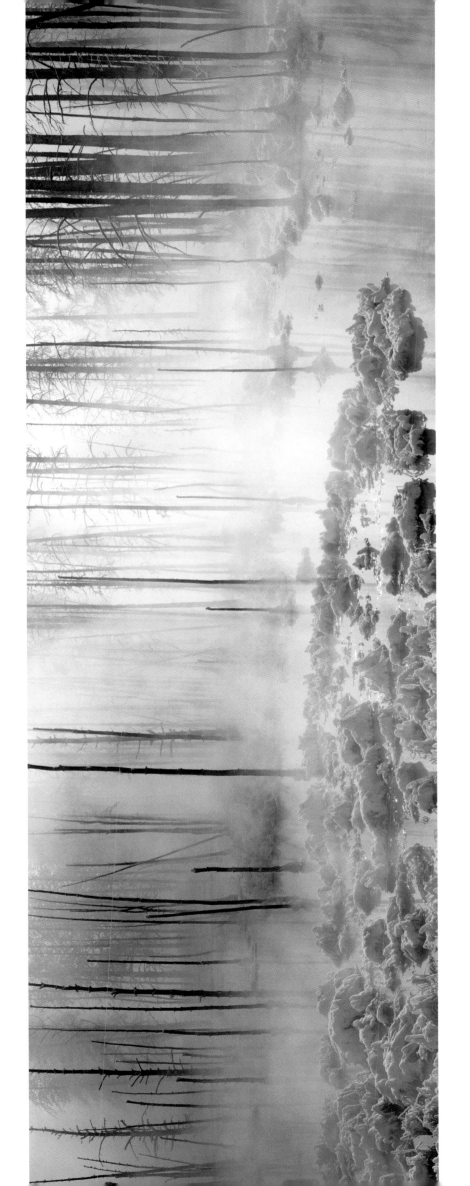

On a frigid January morning a robin's-egg-blue sky is revealed above the valley known as Jackson Hole. Fog rises from the Snake River, breaking into tendrils as it dissolves against the backdrop of the Teton Range, whose highest peak, the Grand Teton, is 13,770 feet high.

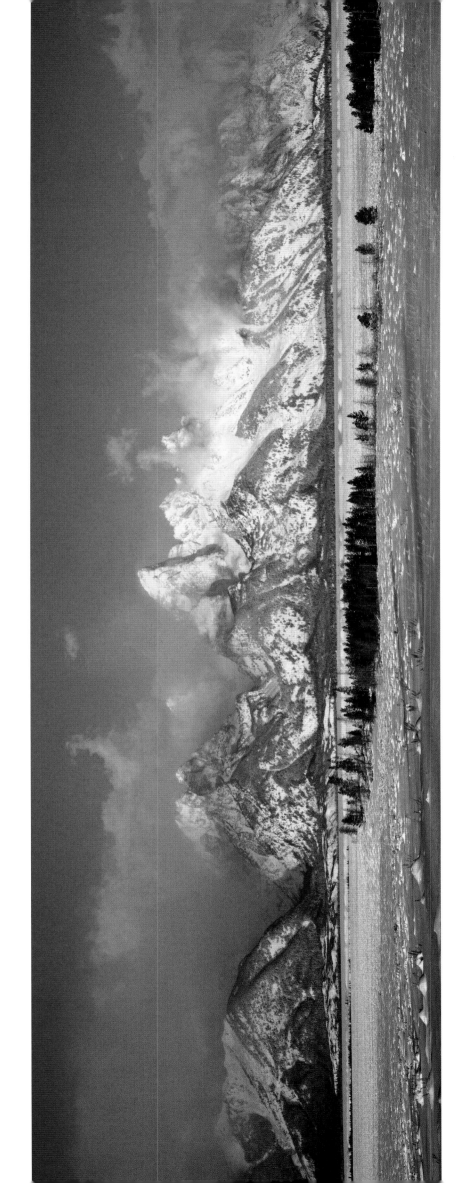

Blanketing the Sulfur Hills, deep snow covers the landscape in Hayden Valley. Home to bison, coyotes and wolves, this area of Yellowstone Park is also prime habitat for grizzly bears, who pass the winter in a state of super-hibernation.

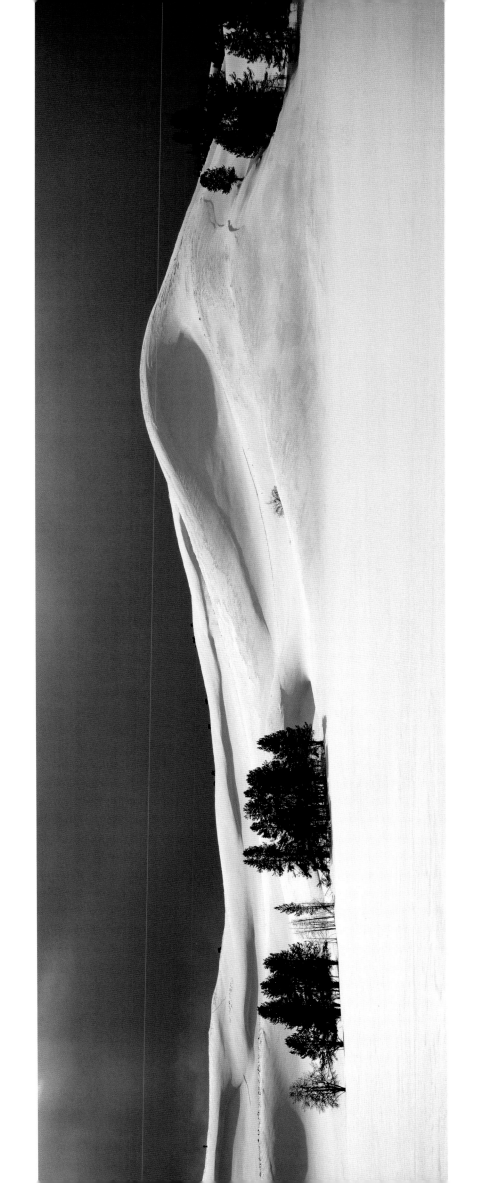

Hayden Valley, Yellowstone National Park, Wyoming, USA, February 1997

The Yellowstone River is a favorite place for trumpeter swans, its waters kept open by warm springs throughout the winter. The largest waterfowl in North America, trumpeters rely on ample submergent vegetation that grows year round in the mineral-rich environment of the Yellowstone.

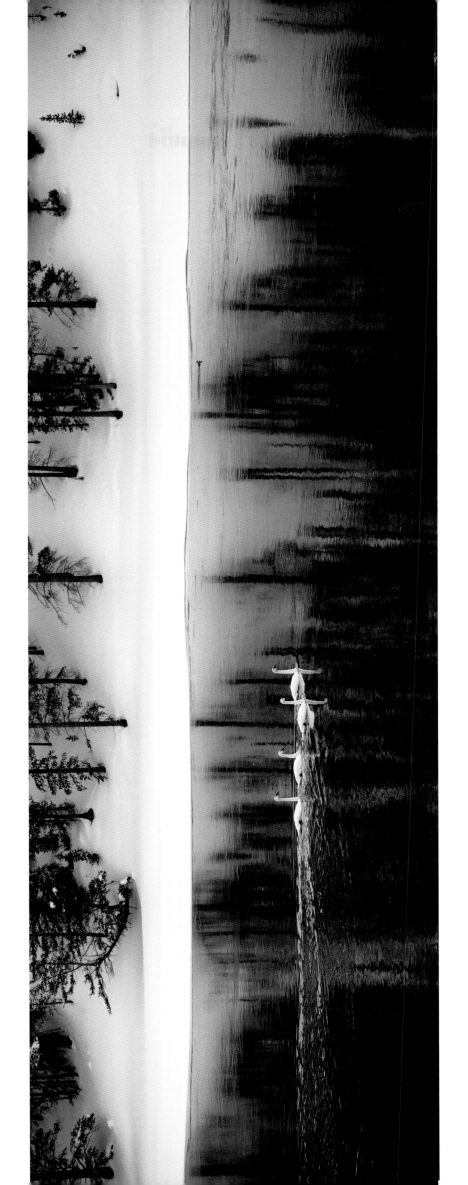

Yellowstone River, Hayden Valley, Yellowstone National Park, Wyoming, USA, February 1998

Off with the old and in with the new: A bison sheds his winter coat and grows new hair in time for the start of August's breeding season. Without their heavy coat, bison are more vulnerable to insect attack and will wallow in dust baths for relief. The new thick, dark coat emphasizes the bulls' hulking shoulders, neck and head.

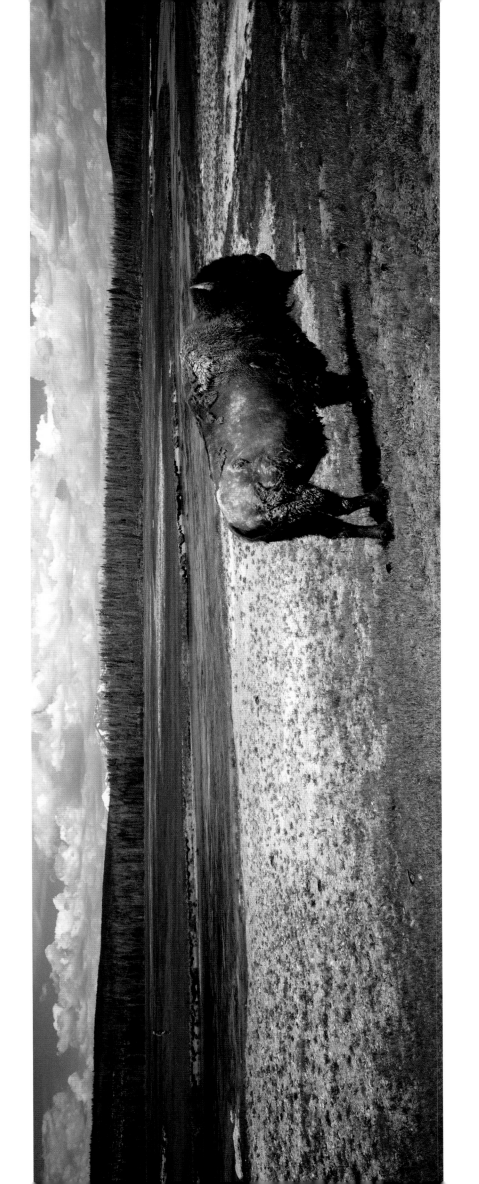

Gibbon Meadows, Yellowstone National Park, Wyoming, USA, June 2002

A ribbon of blue laid against Hayden Valley, the Yellowstone River flows north through the park on its way through Montana. It is the longest undammed river in the lower 48 states and eventually merges with the Missouri in North Dakota. The Hayden Valley was once consumed by the waters of Yellowstone Lake, resulting in abundant marshlands for waterfowl and a notable absence of trees.

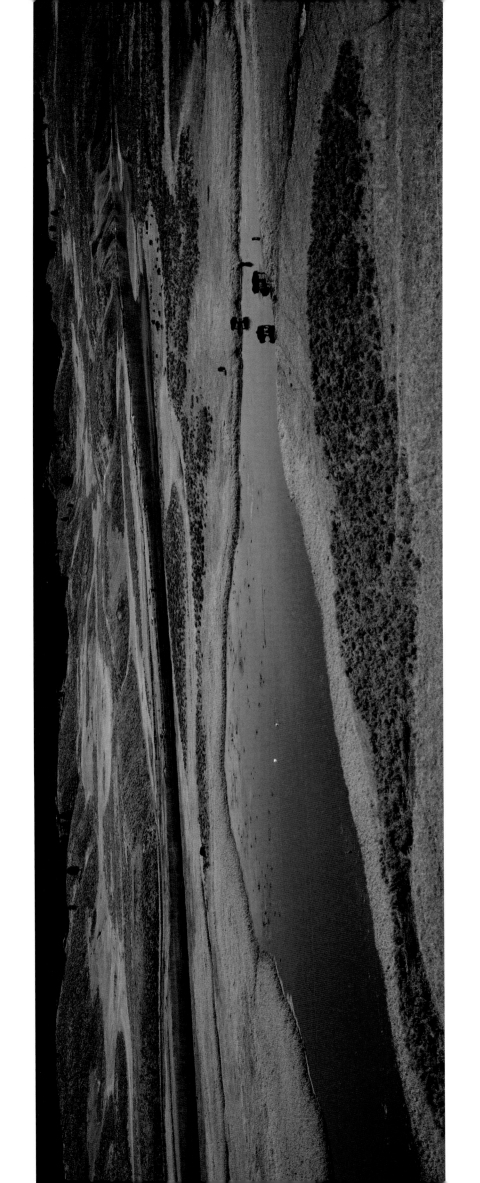

Hayden Valley, Yellowstone National Park, Wyoming, USA, September 1995

Straddling the Continental Divide, Rocky Mountain pond lilies and a downed lodgepole pine offer a small window into Yellowstone National Park. Beavers build dams in ponds like these; muskrats often cache the stalks of the succulent lilies in their burrows.

Overshadowed by first light breaking up a dawn storm across the Tetons, a pair of nesting trumpeter swans lie protected among the bulrush and lily pads. Swans are repeat nesters and will return to previous years' sites to hatch subsequent families of cygnets.

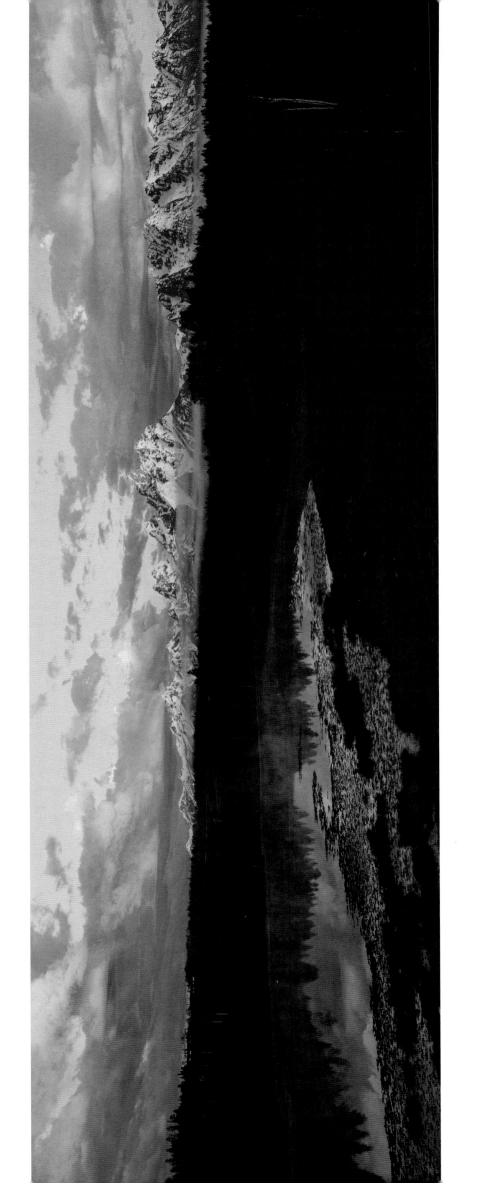

Grand Teton National Park, Wyoming, USA, July 1995

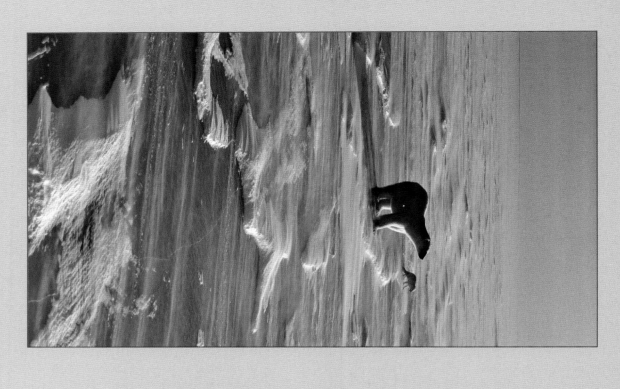

HUDSON BAY

November 1993

Windswept Cape Churchill, the narrow point of land that juts out farthest into Hudson Bay's west side, is the main gathering place for polar bears during the fall. Some have come here regularly for more than twenty years, and many were born in the spruce forest denning area fifty miles to the southwest. As the days grow shorter, the nights cooler and the tundra colors change, the bears head to the coast; the first ones arrive at the cape in early October. Some travel from small, rocky islands farther north, while others come from the inland tundra where they have spent a somewhat lethargic summer, trying to escape the heat and the swarms of mosquitoes. To save their fat reserves, built up over a winter hunting ringed seals on the ice, they do not move long distances. In a state of near torpor, they halfheartedly feed on whatever they can find: from lemmings to beached beluga whales, eider duck and snowgoose eggs to crowberries and cloudberries. They will graze on coastal sedges and eat kelp that has fermented after washing ashore, delicately picking through it in search of mussels and clams. It is a varied and sparse diet during the summer and not enough to sustain them through the long arctic winter. The polar bears of Hudson Bay, like elsewhere in circumpolar regions, are totally dependent on the abundance and availability of one hundred and fifty-pound ringed and six hundred-pound bearded seals.

Hungry bears begin gathering here at the cape because it's the first place the bay ice freezes, giving them the earliest opportunity to hunt their staple of seals. If the temperature does not drop soon enough in the fall to freeze the vast waters of Hudson Bay, the bears' already-too-long near-

fast will take its toll. Conversely, in the spring, if the temperature rises too early and the ice pack melts, the bears will lose their seal hunting platforms and have to return to the tundra prematurely without having built up the necessary stored fat reserves. The polar bears this far south in the Hudson Bay subarctic are the most vulnerable to the Earth's warming climate. Research has shown that the polar bear population in western Hudson Bay has declined from around twelve hundred bears in 1987, when I first visited here, to less than nine hundred and fifty bears in 2004.

By now, mid-November, more than two dozen bears have arrived, among them a huge male bear with a crescent-shaped scar beneath his left eye. It was three years ago that I first saw this bear, who I named Luke after the character in the movie *Cool Hand Luke* because of his attitude and demeanor. Today he is in a very playful mood. Well over a thousand pounds, Luke has a commanding presence and encourages a younger sparring partner half his size to play. He bends his knees to be less intimidating, knowing the play fighting won't begin if he appears too large or will end too soon if he is overly aggressive. Other than the small crescent scar, Luke shows few signs of being a warrior. With his immense head, long canines and powerful paws, he could easily do major damage to any bear. Although play fighting is important for bears to hone their skills and tune their reflexes in preparation for hunting seals, it appears, after years of personal observation, to be done for the pure joy of it.

We awoke at Cape Churchill this morning to a beautiful sunrise with hoarfrost on the grasses, a frost that will not melt in the day's deepening cold. The sun, making a low arc across the sky, backlights the blowing snow and casts an amber glow over the land. To photograph the freezing bay and the snow racing across the tundra, Dennis, our driver, swings our vehicle around to the south. In the distance, almost in a mirage, a female and her two small cubs of the year (known as "coys") appear on the sandy esker to the southeast and are coming our way. A pair of sundogs form above them.

We spend twenty minutes or so photographing the family before the mother spots a male, a quarter-mile away. She pauses and nervously stares, not interested in any confrontations today, maybe too spooked by the fierce weather. Other days this particular female would likely charge all but the largest of bears. Today the scents are confused and there is very little visibility in the whiteout conditions—it would not be wise to charge, especially when other bears might be around. Better to run than to leave the cubs unattended, even for a moment.

The mother and cubs leave hurriedly and go to the frozen bay, where we later find them along the high shoreline. Unexpectedly, the mother rises on her hind feet and stands there, trying to get a better view over the ground blizzard of a bear that has come up behind us. Grabbing the panoramic camera I reflexively shoot the last frame. It is all there: surreal light, blinding snow, windswept landscape and a bear family.

Realizing that the bear behind us is another female and no threat, the family moves down the ridge a short distance, where the mother digs a shallow snow pit. She and the two coys curl up in the day bed for an hour or so before the smaller one starts whining and begging. The mother turns her back to the wind and hovers over the coys as they bury their little heads into her warm and furry chest and are quickly covered by a blanket of drifting snow.

We watch the bear family until dark, when a thin crescent moon rises in the southeast. Returning to camp, we are treated to a dazzling display of the aurora borealis. Samuel Hearne, the famous Hudson's Bay Company trader and explorer, wrote in 1772 that the Cree Indians believe that the northern lights were "the spirits of their departed friends dancing in the clouds; and when [the light] is remarkably bright … they say, their deceased friends are very merry."

This image, titled Born of the North Wind, earned Tom Mangelsen the Wildlife Photographer of the Year award from the BBC in 1994. The judges commented that to witness "one of the greatest wild beasts dwarfed by the immensity of its surroundings is not just a powerful testimony to the survival skills of the polar bear, but a reminder, if we ever needed one, that it is the Earth itself which supports every living thing."

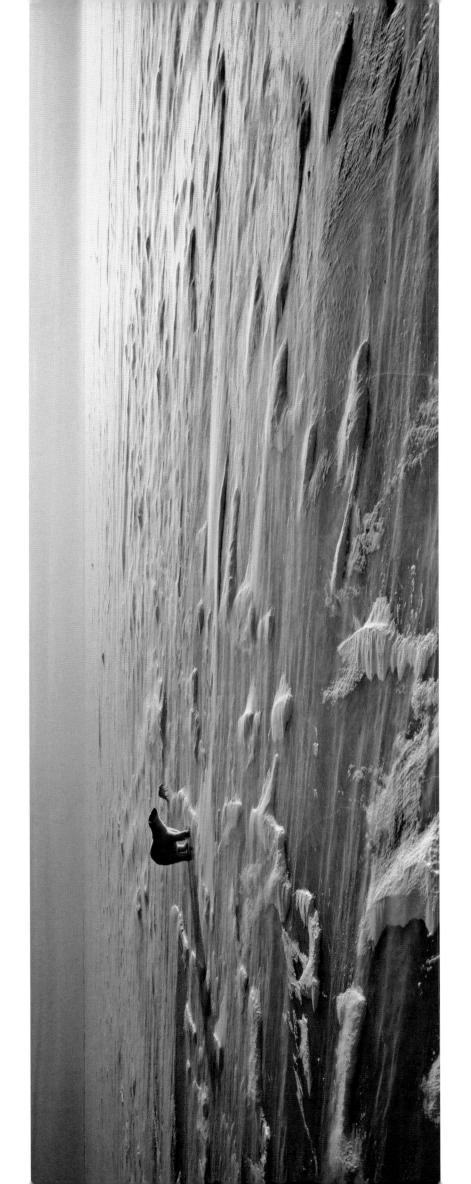

Cape Churchill, Hudson Bay, Manitoba, Canada, November 1993

Sheets of jumbled pancake ice collide violently as they develop into a single frozen mass that will soon cover the expanse of these watery circumpolar regions. Rising temperatures around the world resulting from carbon dioxide emissions are believed to be mostly due to an increase in human activities. Global warming and its implications threaten this icescape and along with it, the great white bears. This ice formation is polar bear country in the making and the key to the bears' long-term survival.

With no ice in sight, a hapless polar bear explores Cape Churchill in early September. The waters between the cape and Gordon Point are the first to freeze, meaning the bear must wait two more months before the bay ice begins to form.

Curling up never felt so good. With winter seemingly eons away, a three-year-old female now on her own naps through the heat of the day, and for good reason. Earlier this same day, she stalked and caught a fledgling Canada goose on the tidal flats of Hudson Bay and spent a long morning sifting through kelp and digging for mollusks along the rocky coast.

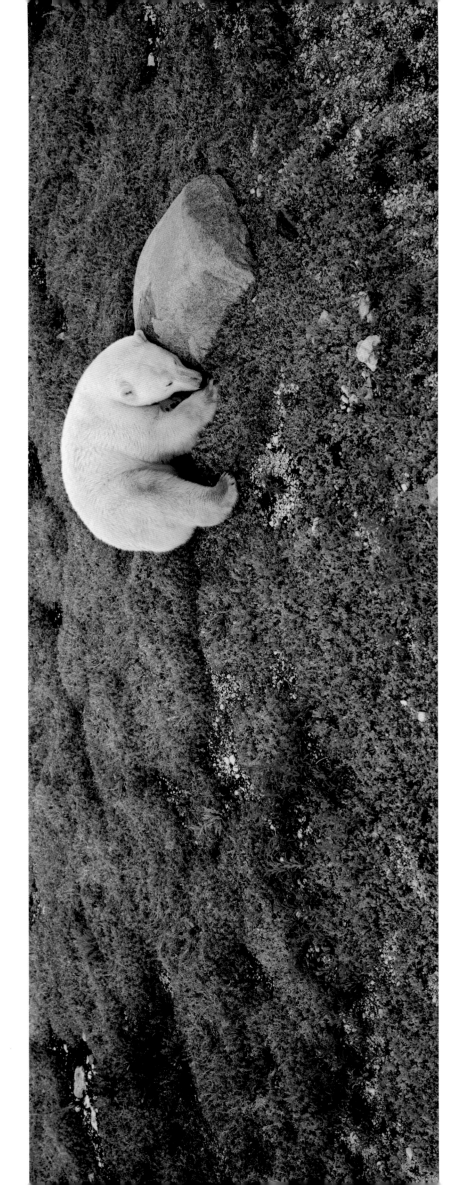

Cape Churchill, Manitoba, Canada, September 1996

241

A crotchety old male polar bear is as much a threat during the lethargic summer months as he is in winter. Females with cubs go to great lengths to avoid males, who will sometimes harm their cubs. For the next eight weeks the seasonal polar bear population will grow as other bears arrive from their summer ranges to this gathering place, the world's greatest concentration of polar bears.

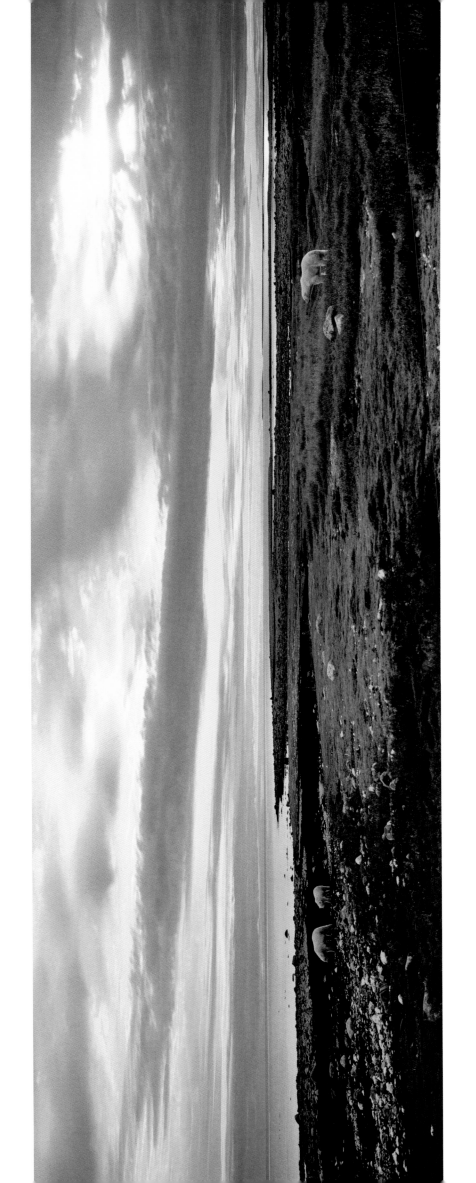

Heavy clouds tease at the hope of an early winter, but the token is a weak one. Wager Bay, an inlet on Hudson Bay's western shore, lies within the ring of the Arctic Circle, six hundred miles north of Churchill, Manitoba, and is one of the last places to lose its ice. Ringed and bearded seals resting on the bay's remaining floes usually attract enterprising polar bears. But now, during late August, even Wager Bay's ice is gone, leaving this landlocked male with few hunting opportunities until the ice forms again.

Cape Churchill, Hudson Bay, Manitoba, Canada, November 1993

Weary from a long session of play fighting, two large males take a break. The same adaptations that allow the bears to survive the brutal arctic cold also contribute to their overheating. To lower his body temperature, one of the bears spreads out on the ice. By exposing the veins near the thin skin of their groin and underside of their legs, bears achieve maximum cooldown in the shortest time possible.

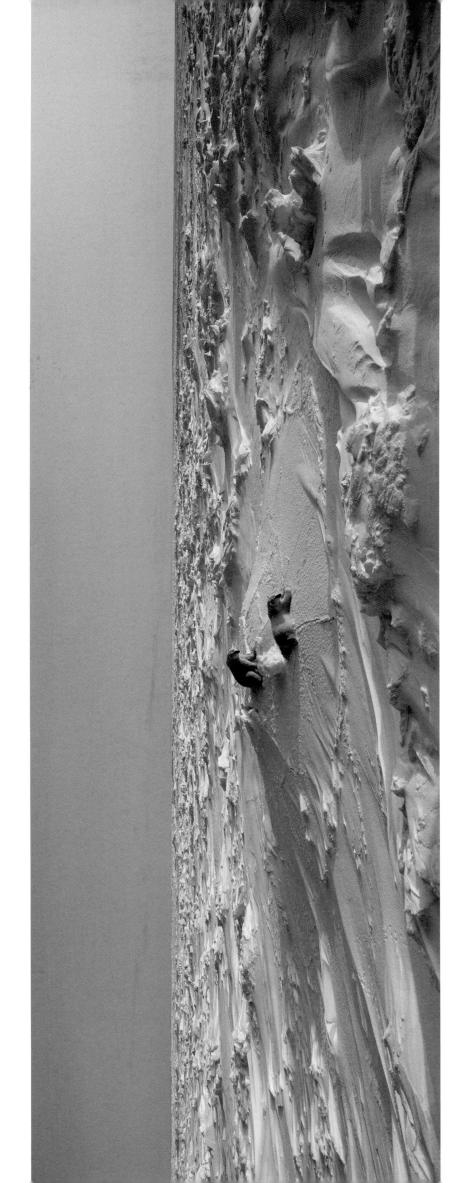

Cape Churchill, Hudson Bay, Manitoba, Canada, November 1991

251

Three days of whiteout blizzard conditions clear to reveal golden northern light and an icescape ripe for voyaging. As described by famed arctic author and naturalist Fred Bruemmer, the polar bear's "sense of sight is about the same as a human's; his hearing is excellent, his sense of smell acute. As our world is primarily visual, his is mostly olfactory. Minute molecular nuances born on the wind tell him about all that lives, and moves, or simply exists in an amazingly large area. The Alaskan Inuit have an ancient saying that a polar bear can smell a whale carcass on the beach from fifty miles away."

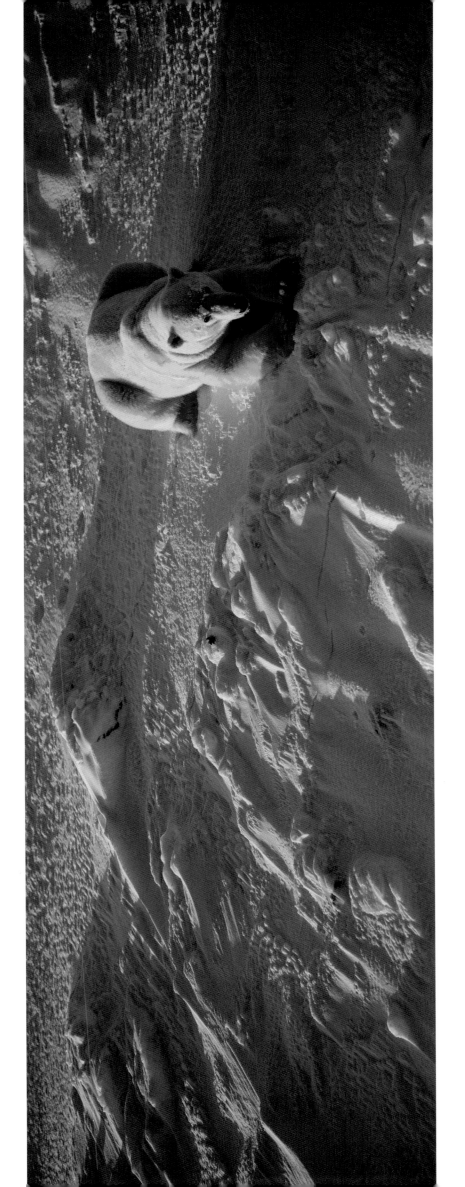

Cape Churchill, Hudson Bay, Manitoba, Canada, November 1996

A towering presence on Cape Churchill, a female polar bear rises to her full height of nine feet to get a better view over a ground blizzard of an approaching bear. The northerlies have arrived, and with them, restlessness builds among the bears. While the ice means the end of the bountiful season for most species, it is just the beginning for the polar bear.

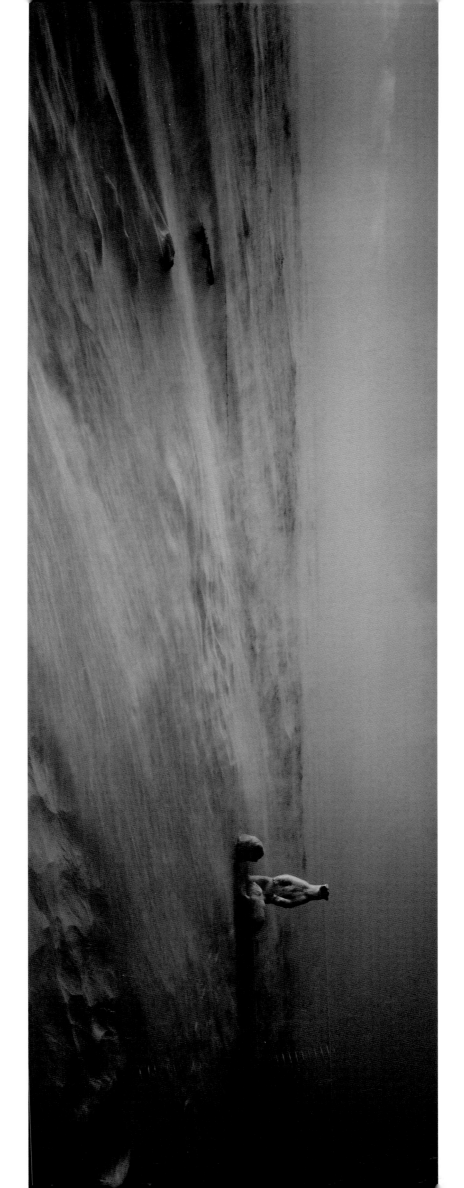

COLOPHON

Published by Universe Publishing
A Division of Rizzoli International Publications, Inc.
300 Park Avenue South
New York, NY 10010
www.rizzoliusa.com

© 2017 Thomas D. Mangelsen, Inc.
Photographs and text © 2017 Thomas D. Mangelsen
Caption text © 2017 Cara Blessley Lowe

Project coordinator: Susan E. Cedarholm
Main text: Thomas D. Mangelsen
Caption text: Cara Blessley Lowe
Copy editor: Jim Stanford
Editorial assistance: Brent Houston
Design: Thomas D. Mangelsen, Susan E. Cedarholm
Layout: Beth Cavanaugh, Jonathan Long, John McGauvran
Photo editorial staff:
 Research: Bissell Hazen
 Color management & image reproduction: Jonathan Long,
 Bob Smith, Richard Jackson, Erik Ko (Global PSD)

2017 2018 2019 2020 / 10 9 8 7 6 5 4 3 2 1

Printed in China

ISBN-13: 978-0-7893-3278-3

Library of Congress Catalog Control Number: 2016952468

ACKNOWLEDGMENTS

The images in this book are a retrospective of nearly twenty years of my panoramic photography and are a synthesis of more than twenty thousand photographs representing six continents. Many individuals and organizations over the years have contributed to the making of this book in one way or another. I thank all of you and for anyone inadvertently not mentioned, please forgive me and know that you are indeed included.

Special thanks to all of those who worked so closely and extensively on this book: in Jackson, Wyoming, Jonathan Long, Bissell Hazen, Bob Smith, Victoria Blumberg and Jim Stanford. In my Omaha, Nebraska, office, Beth Cavanaugh and John McGauvran; in San Francisco, California, Steven Golf and Gina Chiu; in Hong Kong, China, Erik Ko.

A personal and heartfelt thanks to Sue Cedarholm, whose passion, talent and tireless commitment made it all happen. For your patience and understanding when I needed it most, not only with the book but in the field as well. With sincere appreciation for all you do.

A special thanks to Cara Blessley Lowe, who shared many of the experiences and whose creative captions added greatly to the images and whose words make the book sing.

To my friends and associates at Thomas D. Mangelsen Inc. who have helped me in numerous ways, my deepest gratitude for your effort and support on this considerable book project, especially Dana Henricksen for keeping the company on track during all my days in the field. For those who have been so loyal during the past decade or longer: Dan Fulton, Mike Campisi, Mike Miratsky, Steve Kobjerowski, David Gautereaux, Elaine Kubischke, Kathy Hatch, Jeri Somers, Kathy Caniglia, Anne Shreffler, Laura Alleman, Lori Wickwire, Penny Fike, Bob Kennedy, Donnette Manak, Jeremy Caniglia, Todd Bohlmann, Shane Strazdas, Mike Cronin and Carolyn Scrimsher. Much gratitude and thanks to all the craftsmen and production staff, gallery managers and associates and all those who represent me so well and champion my work.

Heartfelt thanks to my companions and friends in the field, for your help and assistance in capturing the images and for greatly enriching the experience: Eric Anderson, Melinda Binks, Fred and Maud Bruemmer, Howard Buffett, my nephews Eric, David and Matt Mangelsen, Thiele Robinson and Jo Stougaard.

Thanks and appreciation to my brothers, Bill, David and Hal, and my nieces and nephew, Annie, Jennifer, Marla, Kristin and Michael, for all the love and support over the years.

Sincere thanks to my many friends and colleagues for their inspiration, encouragement and guidance: William Albert Allard, Bill Allen, Marc Beckoff, Jodie Blum, Jim Brandenburg, Elisabet Brandt, Janie Bullard, David Burnett, Yvon and Malinda Chouinard, Rich Clarkson, Jodi Cobb, Dennis Compayre, Lisa Connor, Sandy and Chip Cunningham, Patricio Robles Gil, Al and Tipper Gore, Dan Guravich, David Alan Harvey, Kim and Melanie Heacox, Ralph Lee Hopkins, Michio Hoshino, Brent Houston, Richard Jackson, Paul Johnsgard, Nickson Kassim, Jean Keene, Chuck Keim, Mike Kissane, Bob Kuhn, Lars Jonsson, Frans Lanting, Annette Lanjouw, David Lenz, Mary Lewis, Jay Maisel, Penny Maldonado, Timothy Mayo, Jeanne Mertz, Steve Miller, David Muench, Jan Nystrom, DeeAnn Pederson, Shaun Powell, Laura Quinlivan, Ed and Lee Riddell, Galen Rowell, David Schonauer, Toby Sinclair, Dhruv Singh, Leif Skog, Len and Bev Smith, Tim Soper, Derek Stonorov, Jon Stuart, Rikki and Jack Swenson, Dyanna Taylor, Lisa Trotter, Kent Ullberg, Doris Valencia, and Tom Walker.

A very special thanks to Jane Goodall for your enduring friendship and for writing a beautiful and eloquent foreword. I am eternally grateful and have the deepest appreciation and respect for all you do for wild places, wild creatures and your tireless and unselfish efforts to help bring about peace on earth. You have given us "Reason for Hope."

Images of Nature® is a federally registered trademark of Thomas D. Mangelsen, Inc., Omaha, NE.

Limited Edition prints and Thomas D. Mangelsen's books are available through Thomas D. Mangelsen, Inc., Images of Nature®
13303 F Street, Omaha, NE 68137
800-228-9686
www.mangelsen.com
service@mangelsen.com

Images from this book are available for licensing through Thomas D. Mangelsen, Inc., Images of Nature® Stock Agency
PO Box 2935, Jackson, WY 83001
307-733-6179
www.mangelsenstock.com
photo@mangelsenstock.com

Images in Front Matter

Page 3: Gold Harbour, South Georgia, December 2005
Page 5: Manu National Park, Peru, August 2000
Page 7: Tehachapi Mountains, California, USA, April 2003
Page 8: Lake Ndutu, Serengeti National Park, Tanzania, February 2002
Page 10: Platte River Valley, Nebraska, USA, March 1998